PORT OF CULTURE

To my parents and sister, thank you for always being there for me.
To my Nan, wish you were here.

First published 2008 by
Liverpool University Press
4 Cambridge Street
Liverpool L69 7ZU

Text and images copyright © 2008 Pete Carr
Foreword © 2008 Andy Roberts

www.petecarr.net
www.vanilladays.com

British Library Cataloguing-in-Publication data
A British Library CIP record is available

ISBN 978-1-84631-170-3

Designed by March Graphic Design Studio, Liverpool
Printed and bound by Gutenberg Press, Malta

PORT OF CULTURE

The photographs of Pete Carr

LIVERPOOL
UNIVERSITY PRESS

Foreword

I had accepted a place at Liverpool University to read Law. Excited, I told my local newsagent in North London that I was off to Liverpool. 'What a coincidence,' she said, 'I've got an uncle in Leeds!'

I arrived in Liverpool in October 1965. 19 years old, unworldly, but eager to grow up. I suppose I had a slight advantage over the other students at the University, as I had recently returned from three weeks performing at the Edinburgh Festival, where I had met a gaggle of colourful people, including the Scaffold and Adrian Henri. The thing was – I had no idea when we met that I would be living in their city two months later, and I had no idea how to make contact with any of them now I was there.

In reality, the Scaffold had scared the pants off me! Roger seemed so much older than me and really clever, Mike was a Beatle-brother and musoglamorous, and the two Johns, Gorman and Hewson (their roadie/stage manager), spoke with an accent that might as well have been Balkan for all that I understood of it.

In 1965 Liverpool was considerably different to the smart, confident, moneyed Euro-city of today. As my train approached Lime Street that first time, the soot-black Victorian railway architecture of Edge Hill showed how it would be, gothic and gloomy. In those days there were setts all through the University streets, and the imprint of the City's fathers, and its industrial heritage, ran deep throughout. The Catholic Cathedral was still a hole in the ground, the original Cavern still rocked, the Scottie Road area hosted Paddy's Market close to where the new tunnel now dives under the Mersey, you could drive down Church Street in both directions, the ferries ran non-stop and there was precious little sign of the huge changes to come. Before the planning excesses of the 1960s, the monochrome terraces divided like ribs from the spine of Upper Parliament Street, and within a year that was my home too – 64 Canning Street.

I could have obtained my degree and left, like so many others, after three years, without achieving any rapport with Liverpool at all. The difference for me was sheer accident – on my first day there, I was browsing the shelves in Wilson's bookshop in Renshaw Street (next to Lewis's and now part of Rapid Hardware) when I literally bumped into Roger McGough, browsing in the opposite direction. Within days I was drinking in The Phil and The Cracke every night, and within months I was onstage, first with Roger, then Adrian Henri, and by the summer of 1966 I was the entire band for the Scaffold's pre-Edinburgh week at the Everyman Theatre. My future was sealed.

The more work I did with Adrian, the more I came under the influence of the City's greatest admirer. Ade loved the pubs, the streets and houses, and above all, the people of his adopted home. He adored the old graveyard of St James, between the Anglican Cathedral and Gambier Terrace. Overgrown and ominous, the graves and necropolises told of the richness of Liverpool's past, stoical in its misery – Don McCullin, then a war photographer on a break from assignment in Vietnam, shot a roll of black and white for the Liverpool Scene there, with the band ranged between monuments to the dead of long-closed children's homes.

Another of Adrian's friends, also a war photographer, was his schoolmate, Philip Jones Griffiths. I remember him sitting in The Grapes (Peter Kavanagh's in Egerton Street), happily snapping the customers, while extolling the virtues of his new Minox miniature camera. Just like the telly it was a black and white world, then. If you shot in colour it still looked black and white, soot and whitewash, a piano-key town.

Contrast all this unashamed personal reminiscence with the joy of this book of Pete Carr's photographs. The wild abandon of the fireworks for the launch of the Year of Culture, the deeply saturated skies offsetting the familiar buildings of his waterfront shots, the Catholic Cathedral crouching like a giant predatory spider. Did it always look like this? Possibly, but Pete has found it, captured and translated it for us all to marvel at.

And what would the old girl be without her people? Walking the dog, hurling their righteous anger in the streets, dancing, singing, kissing, building and playing. I don't think it is possible for anyone who has even a chance acquaintance with life on Merseyside, cultural or popular, mundane or celebratory, not to recognise the spirit in these images, or the skill which brings them to life. This is a fascinating book – I hope it sells by the truckload. And I hope that Liverpool, the town that moulded me into an adult, continues to flower and gleam in the uncertain future. And I hope Pete is there to record it for us.

Andy Roberts
Brighton, 5 August 2008

4

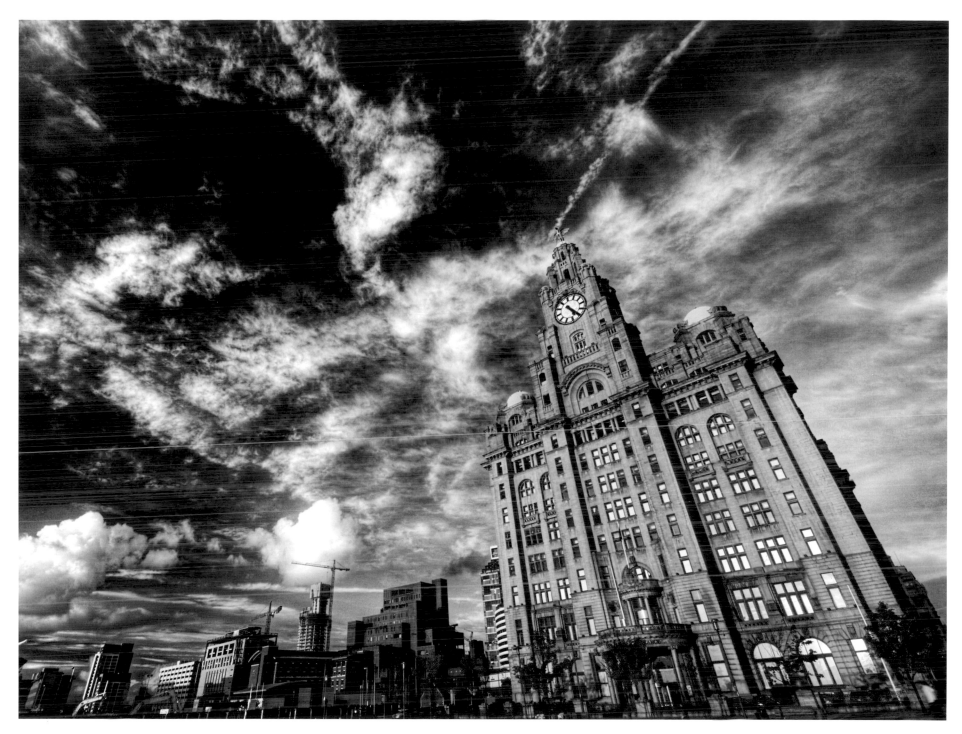

The Liver Building and Princes Dock 5

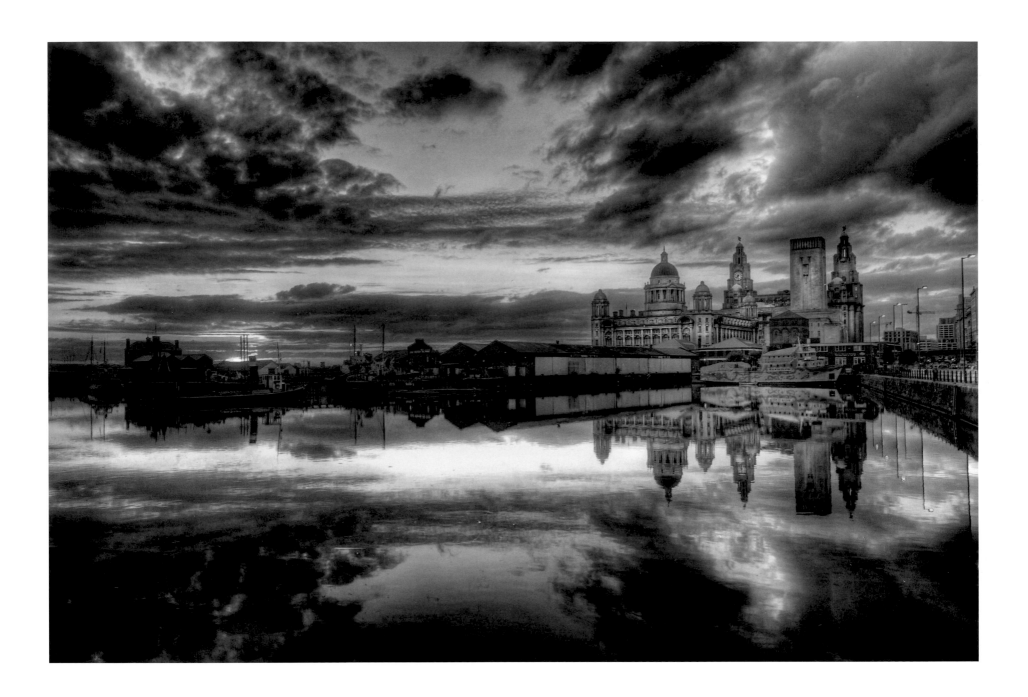

6 Sunset over Mann Island

Introduction

In 2004 I started a website, a photoblog. Back then it was simply a site for me to dump photos on whenever I felt like I had something worth showing off. There was no real focus to it. After running the site for a few years I found my feet in photography. I no longer wanted to photograph just 'anything'. I knew what got me out there: people and places. More specifically, the people and places of Liverpool.

Since creating the photoblog I've learnt more about Liverpool and its people. I've met so many great people through it and seen so many great places. Despite studying in Liverpool through 1997–2001, and having family there, I didn't really know a whole lot about the city. Of course I knew the key places: Albert Dock, the Three Graces and Sayers. However, I didn't know Duke Street from Dale Street.

So, armed with my Canon 10D, I started looking for things to photograph in Liverpool. I started hearing about events like the Mersey River Festival, the *QE2* arriving, and the Brouhaha International Street Festival. Fun events that allowed me to get in close and photograph people. When there were no events to photograph, I'd be out looking for nice cityscapes and interesting angles.

I learnt a lot about Liverpool by doing this. Most of all I saw how quickly it was changing. I knew that by taking photos I could document these changes. For example, some of the early photos on the site are of the rides on Chavasse Park which which is now Liverpool One. The area around Mann Island and Albert Dock is also in a state of change. One of my favourite photos is of the Three Graces reflected in the dock at sunset. It's impossible to retake that photo now. The new Museum of Liverpool is being built on the left-hand side and the warehouses have been demolished. Soon the new buildings will block the view of the Three Graces.

The same can be said of the people. In ten years' time fashion will have changed and the look on the street will be different. I'll have photos of what people were like in 2008. With Liverpool changing so quickly and the Capital of Culture year fast approaching I decided to rebrand my website from just my site to a site documenting Liverpool.

My site was initially inspired by David J. Nightingale's 'Chromasia', which focused on Blackpool. His photos inspired me and changed my perception of Blackpool. In some way I hope my site can do the same about Liverpool. I can use my camera to document the people and places and then show them to the world. Liverpool is a fantastic city and my only aim is to show this.

I write this in the middle of the Capital of Culture year knowing that I can go out tomorrow and take a good photo of something in Liverpool. Perhaps it will be someone in town. They're always great to photograph. Sure, they'll look at me funny but often if I ask they're happy to stop for a photo. I can go to a gig and capture some random unsigned musician playing a fantastic song. I can wander round at sunset and capture the best light that you'll get anywhere in the country against that stunning skyline.

The photos in this book are just the start. 100 of the best from the past few years of documenting Liverpool. I could spend my life documenting the city. Who knows what will happen in 2009. Who knows what will happen in 2029. Good or bad there will always be photos to take here.

The city is amazing right now and it can only get better.

Pete Carr

www.petecarr.net
www.vanilladays.com

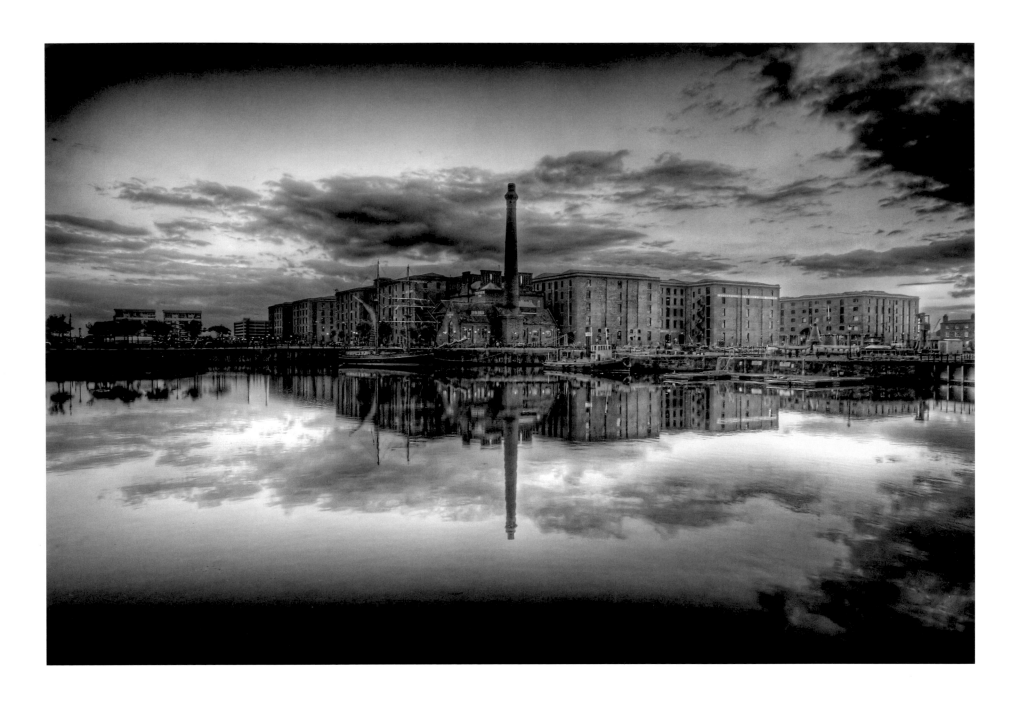

Sunset over Albert Dock

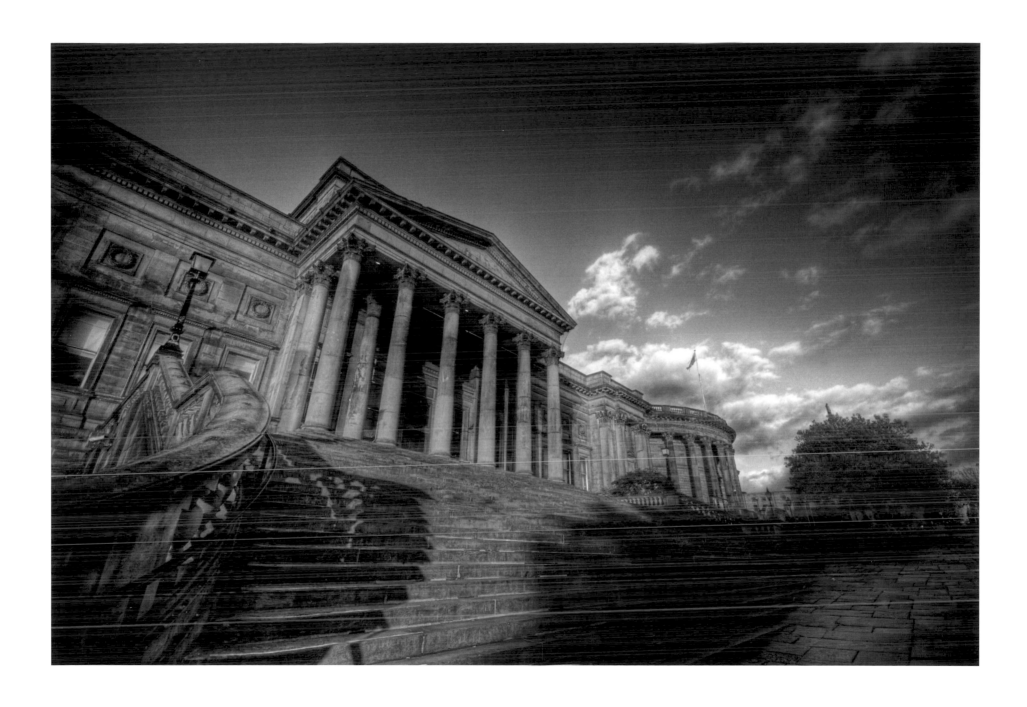

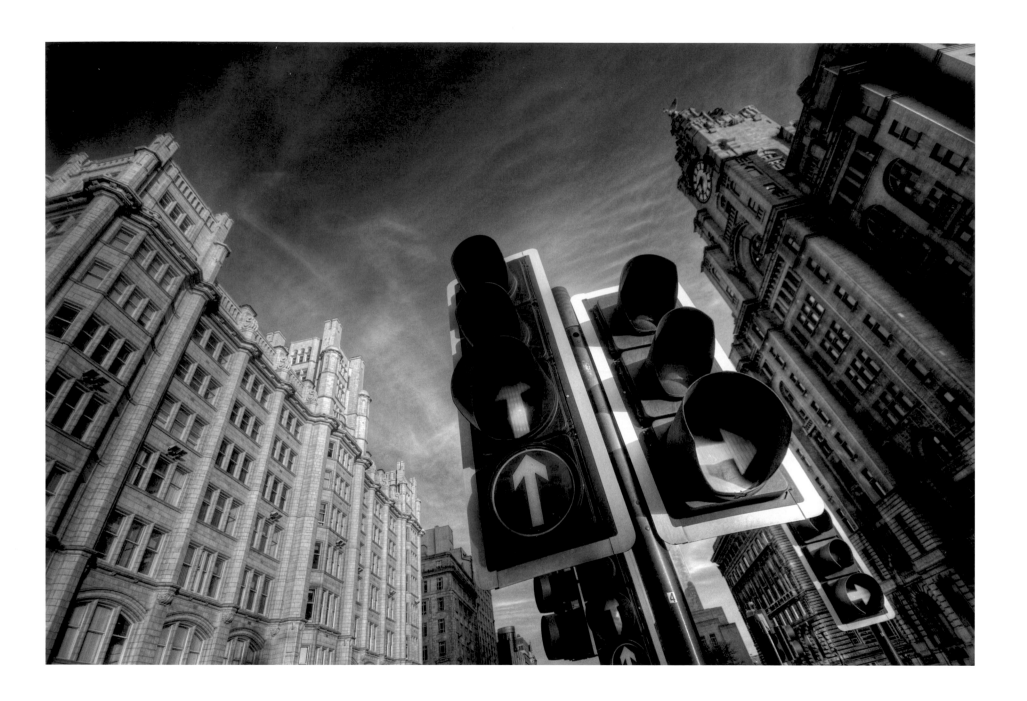

Liver Building and Tower Building from the Strand

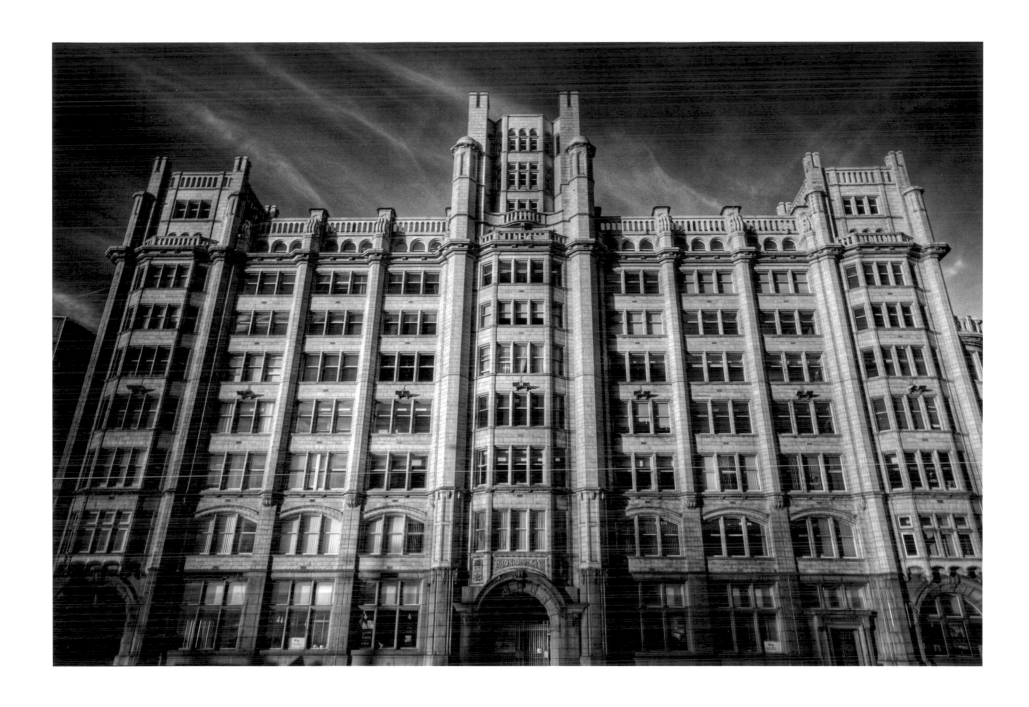

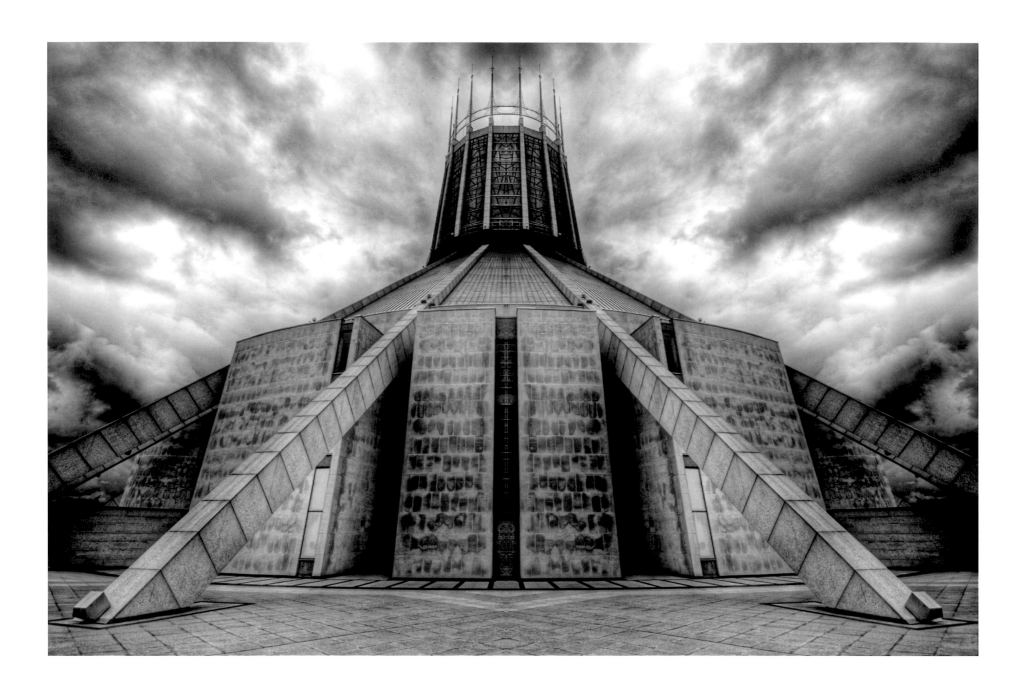

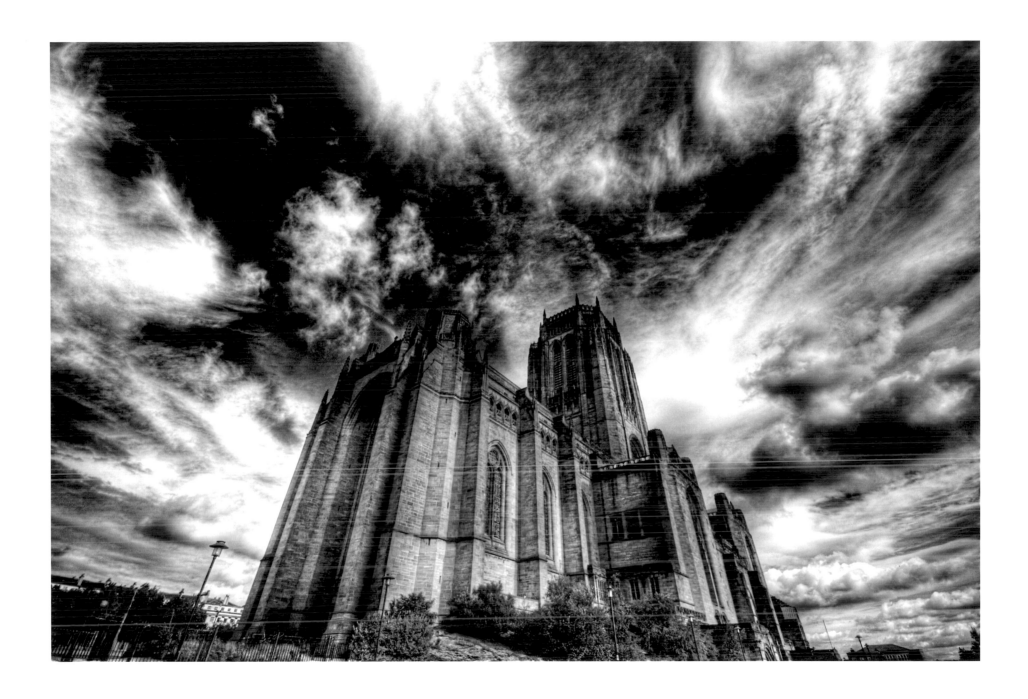

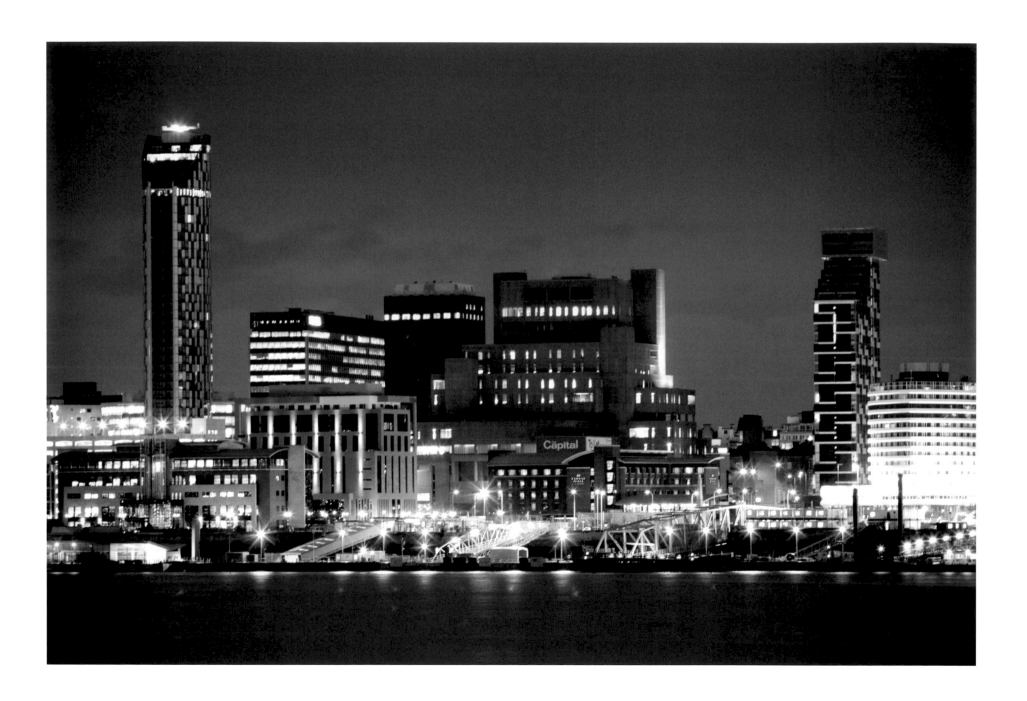

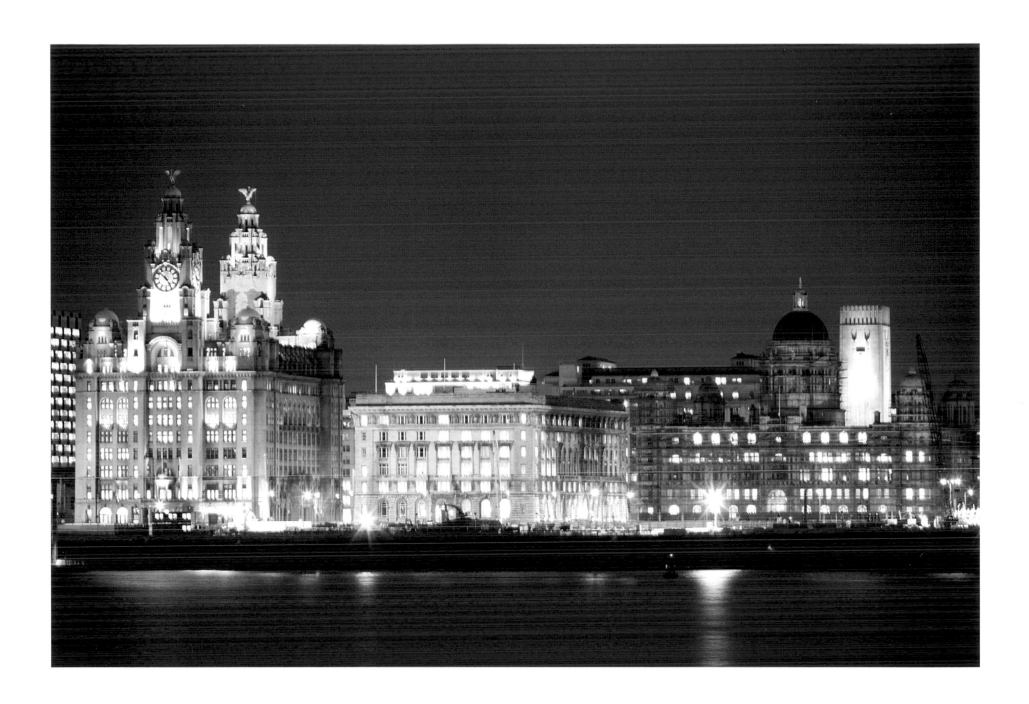

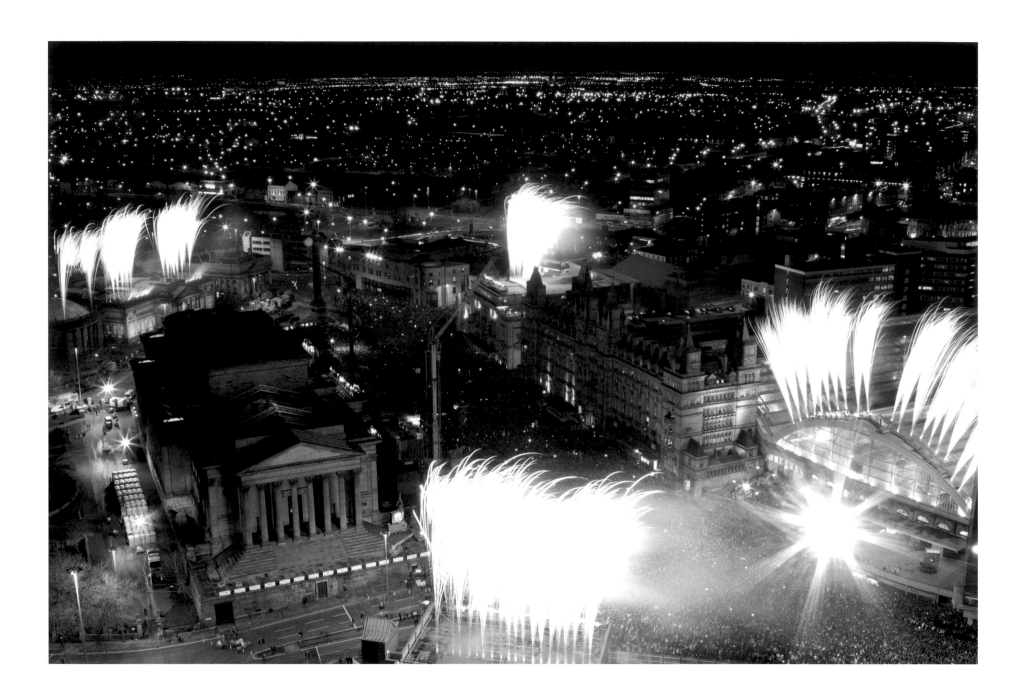

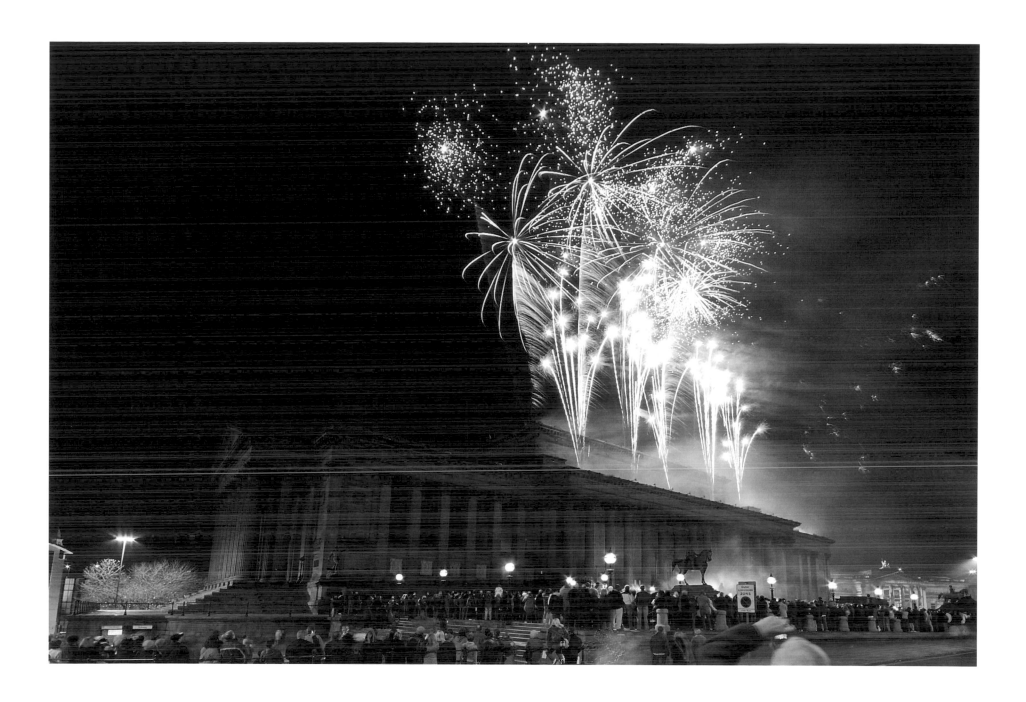

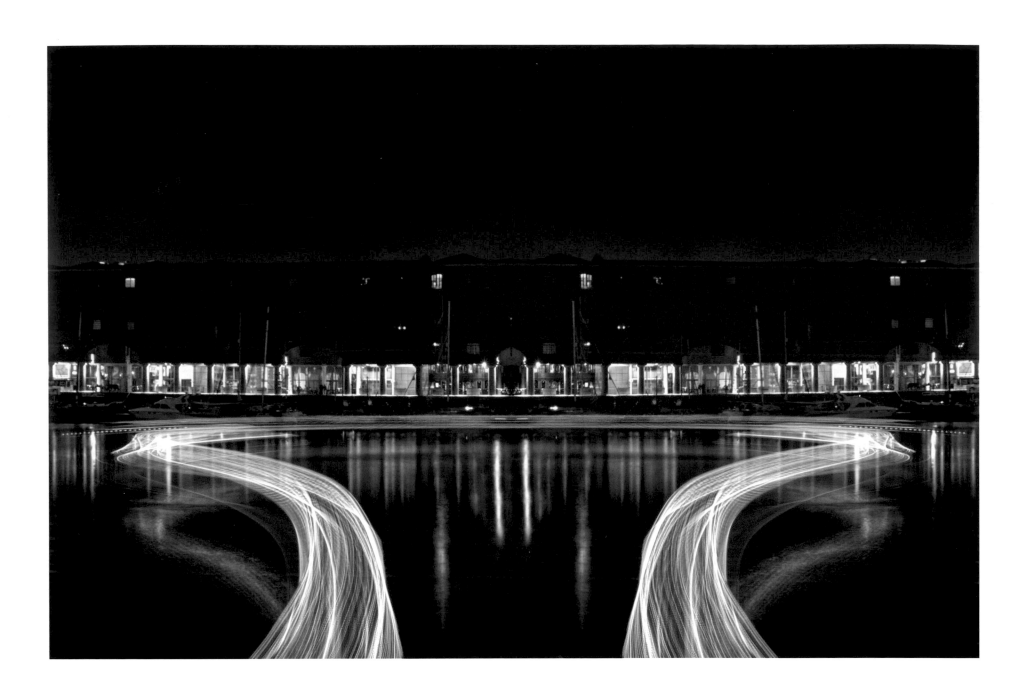

18 A narrow boat illuminating Albert Dock

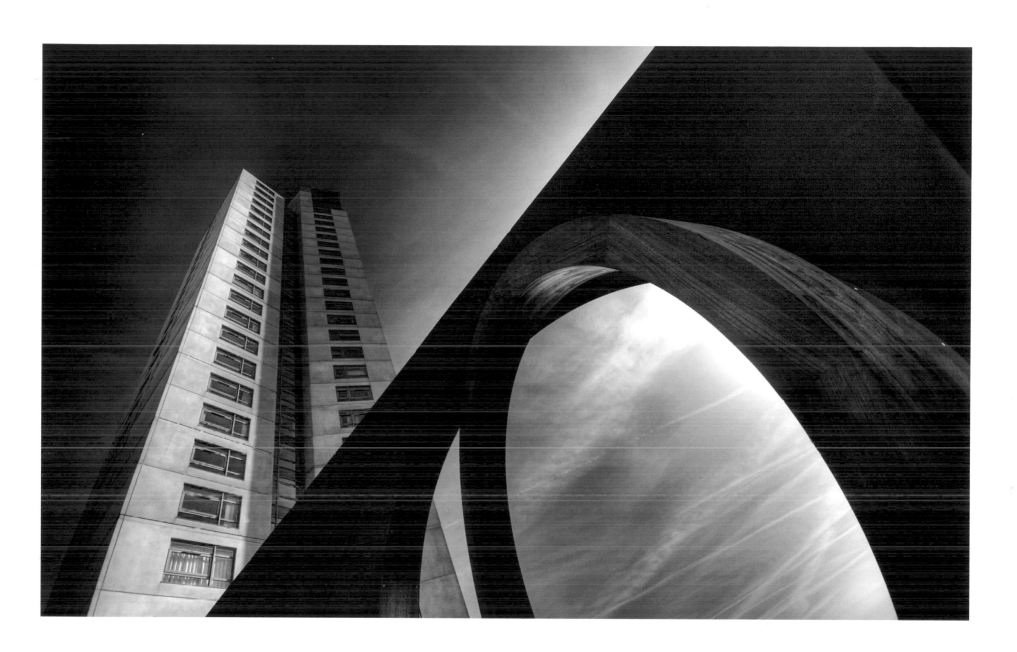

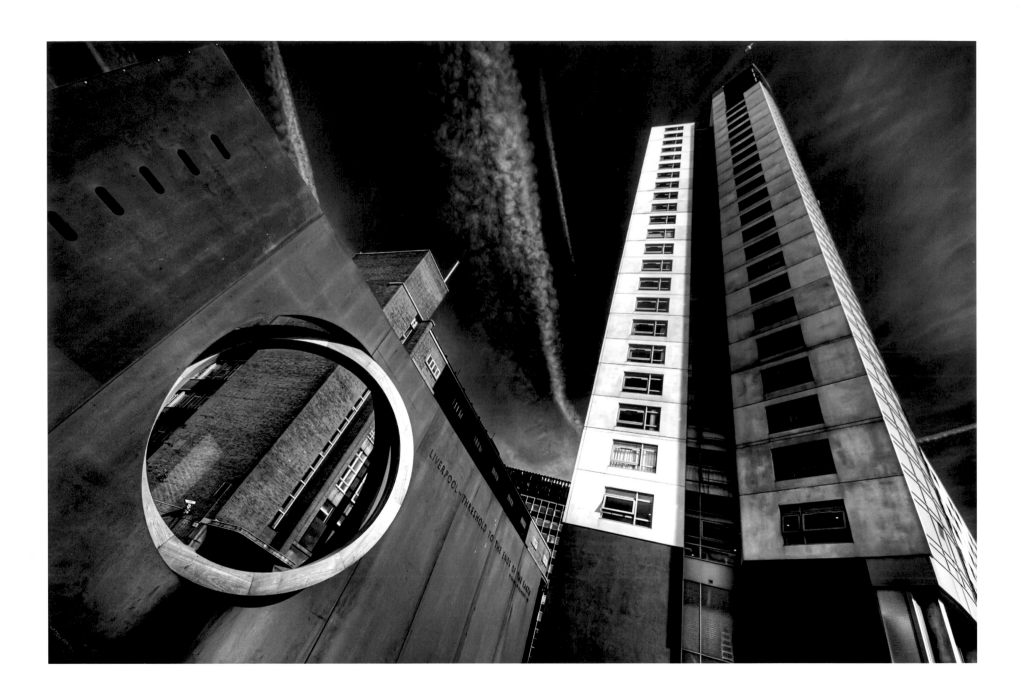

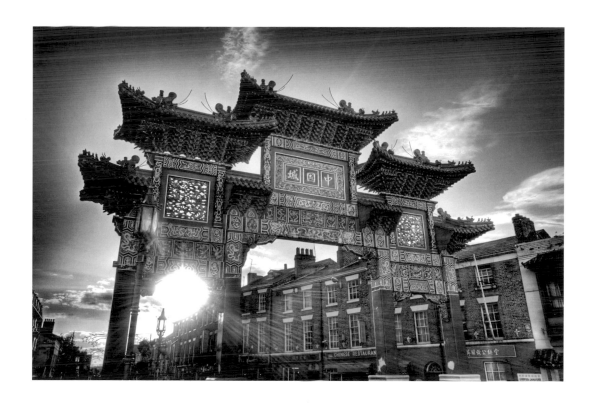

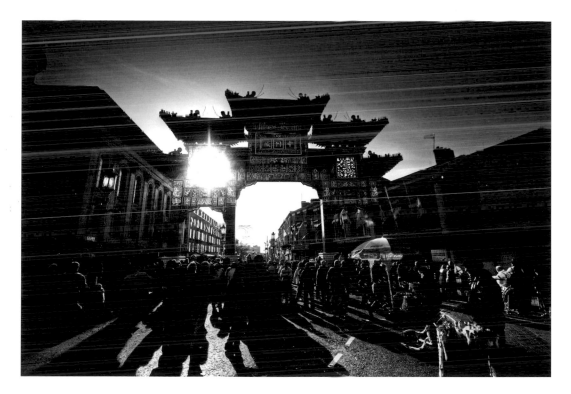

TOP: Chinese Archway, Chinatown BOTTOM: Chinese Archway during Chinese New Year, 2007 **21**

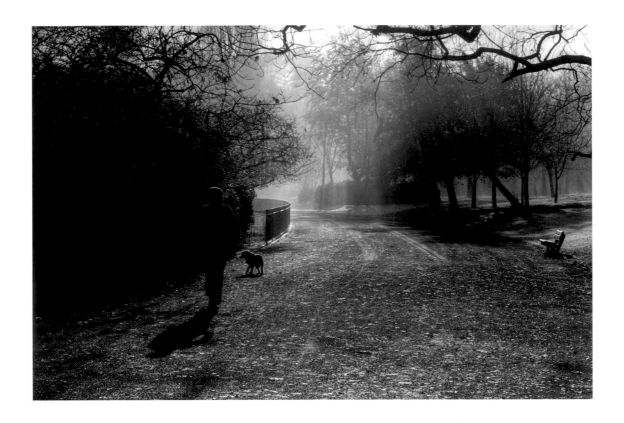

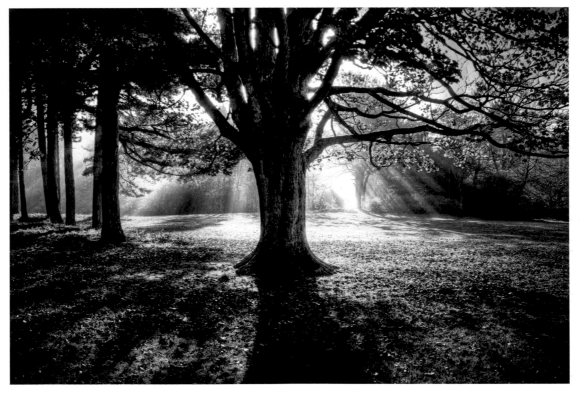

Early November morning in Sefton Park

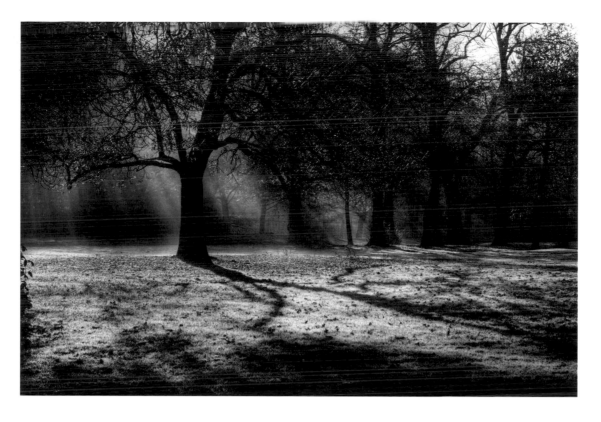

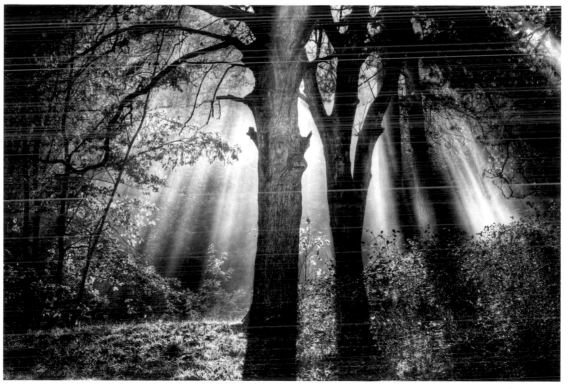

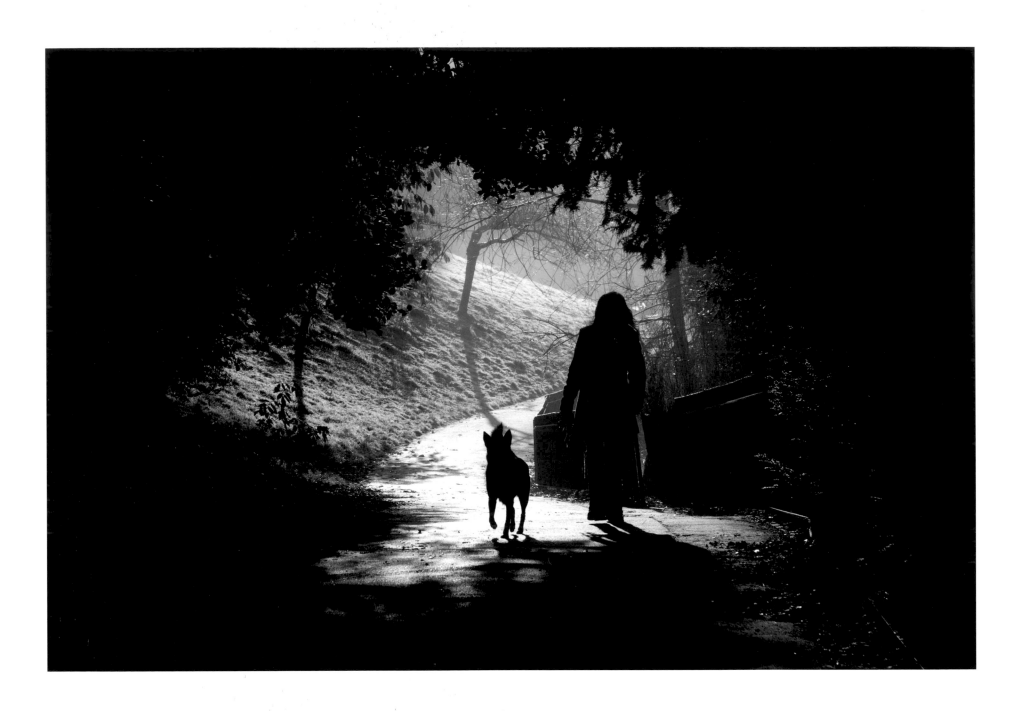

An early morning in Sefton Park

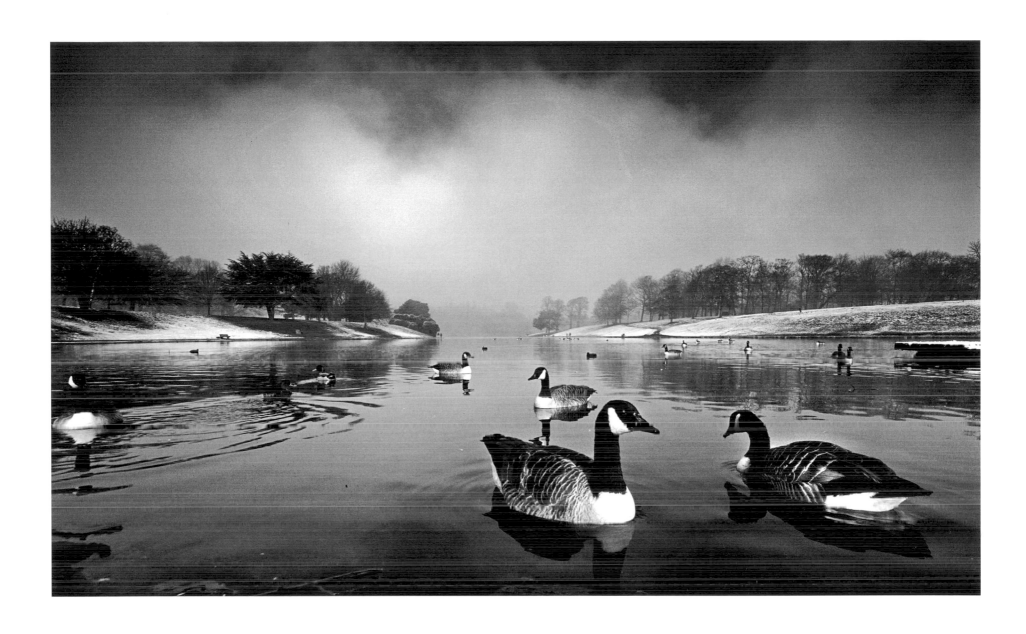

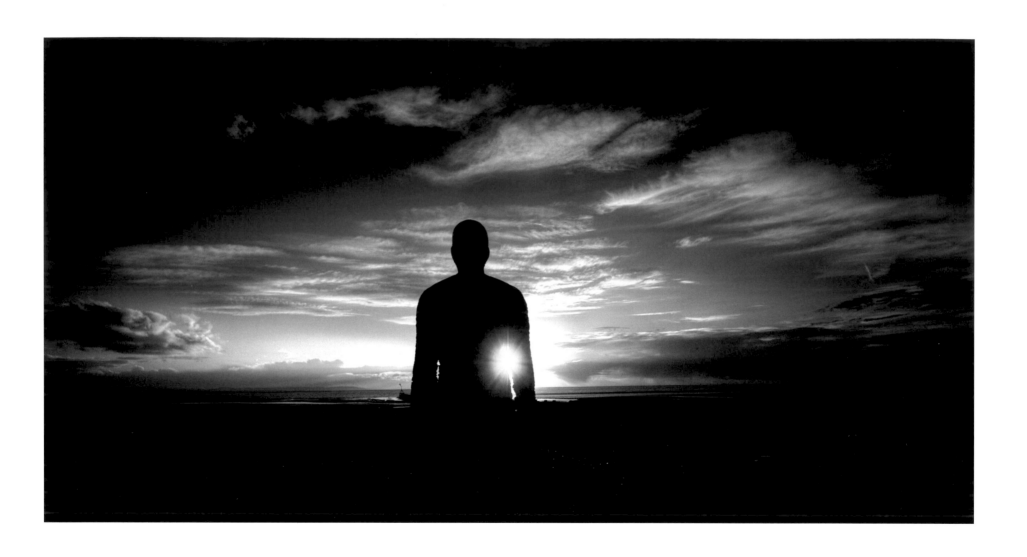

26 Antony Gormley's *Another Place* at Crosby beach

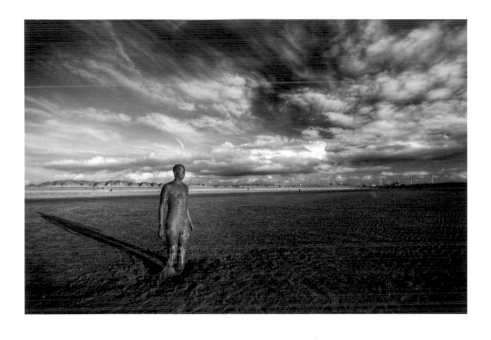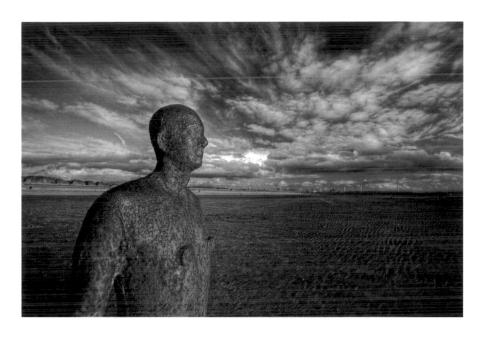

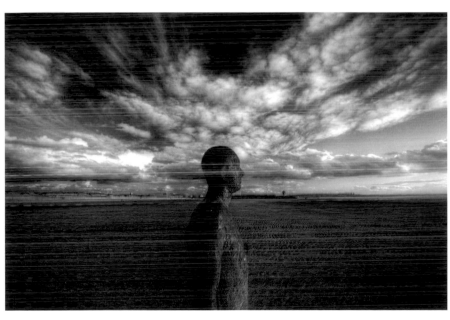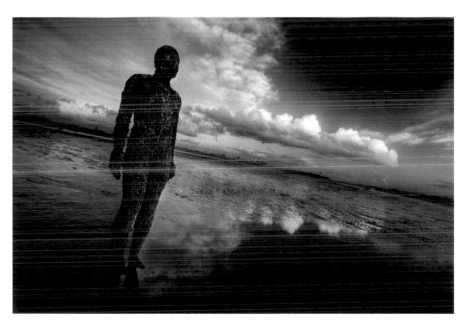

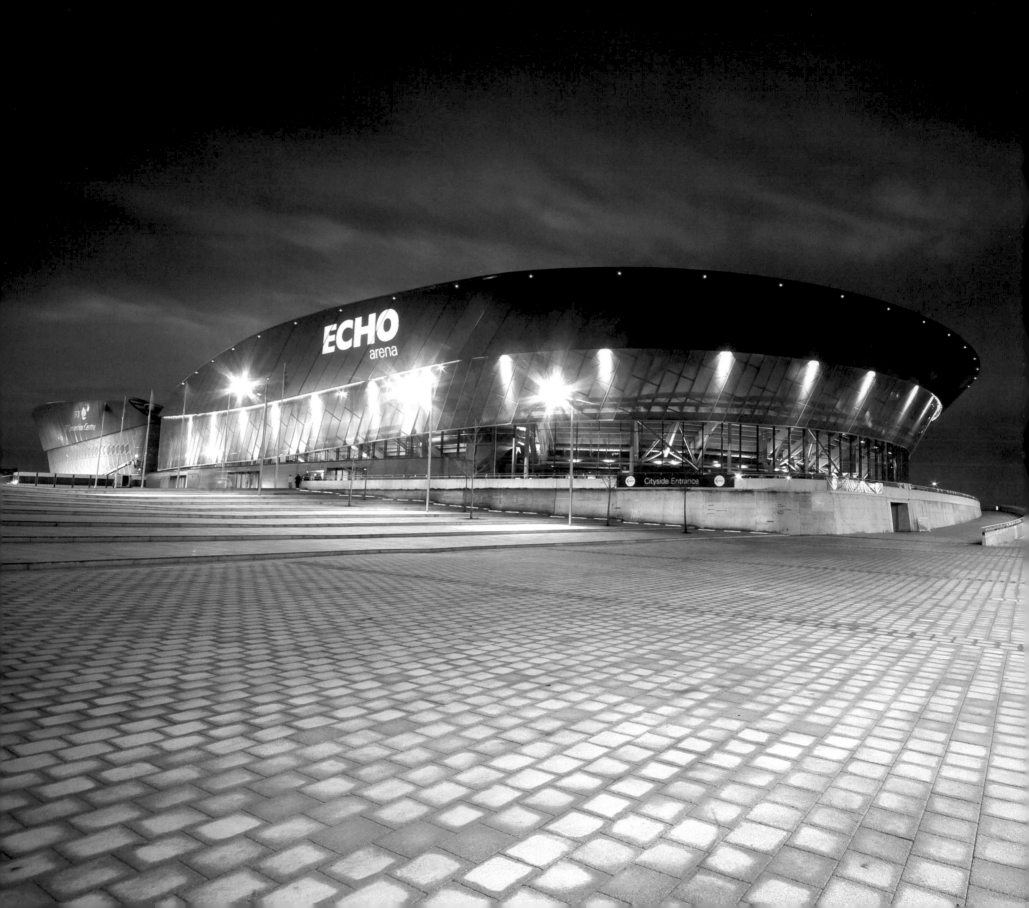

The buildings

Liverpool has a World Heritage site and more Grade I and II listed buildings than any other British city outside of London. From the grand St George's Hall to the Bluecoat to the Three Graces, Liverpool isn't short on amazing architecture. The Anglican Cathedral is simply epic. It is a giant of a building standing on the skyline and its sheer size scares me. I feel so small standing beneath it and simply can't imagine that people built it. On the other end of Hope Street stands the Metropolitan Cathedral. It is a complete contrast to the Anglican Cathedral and looks like something from a science-fiction movie. There are the elegant Georgian houses around Liverpool 8 and Falkner Square. At the other end of town is the business district with its modern buildings filled with glass instead of stone. However, the best thing about Liverpool's architecture is that you can stand on the Wirral and take it all in. The cathedrals, arena, tall buildings, Albert Dock, and of course the Three Graces. At sunset the entire skyline glows. It's simply stunning and I can't think of any other city in the UK that has such an amazing skyline.

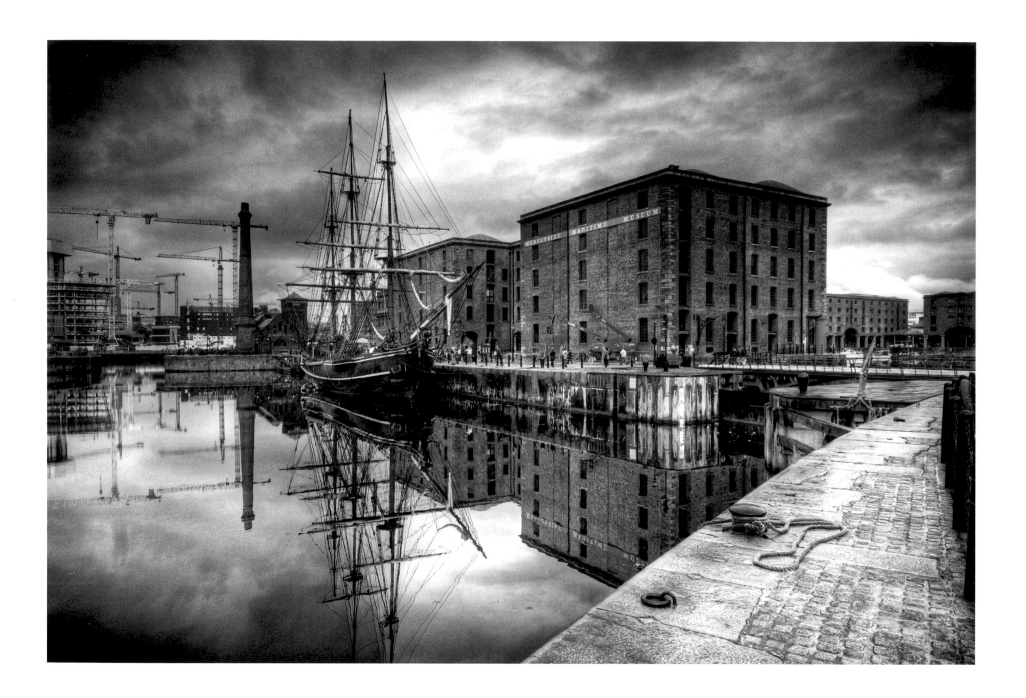

30 Canning half-tide dock and Albert Dock

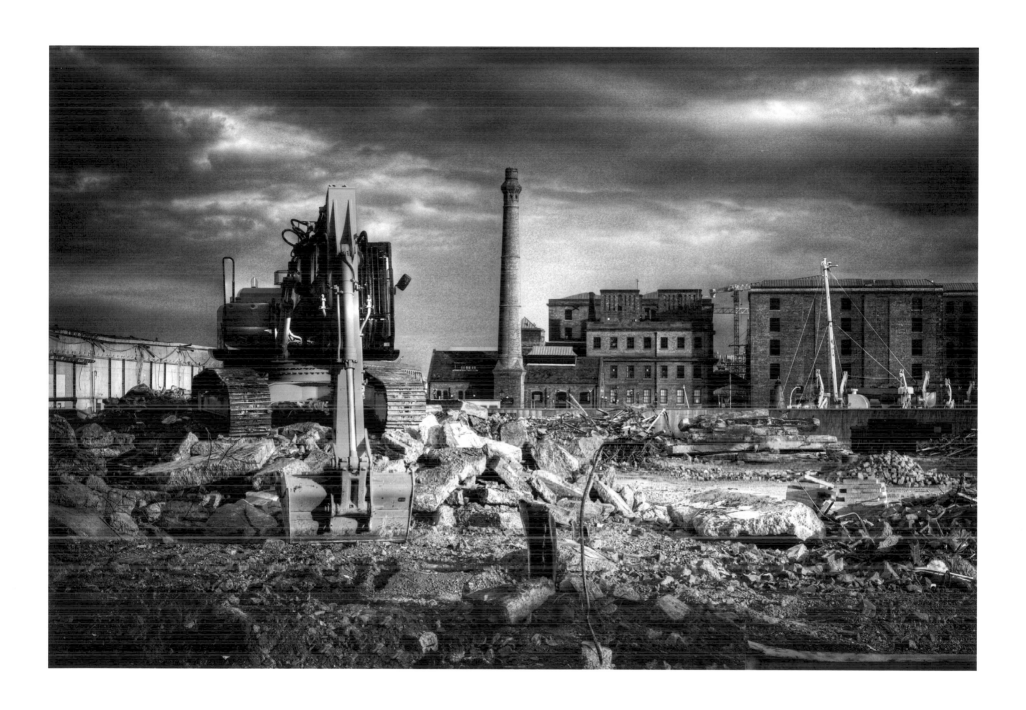

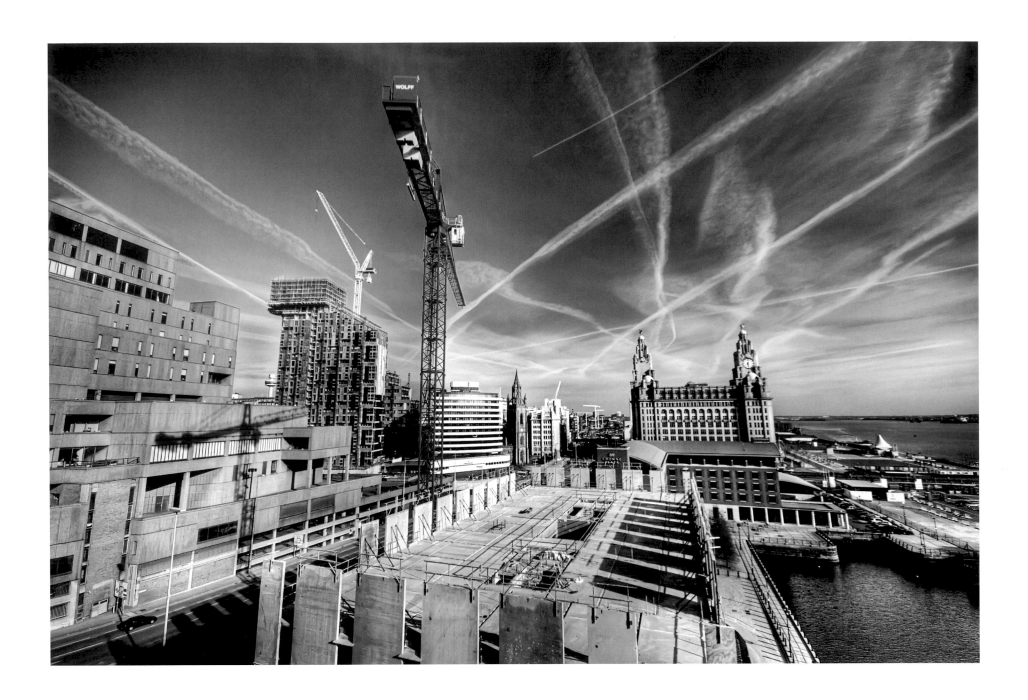

Construction at Princes Dock

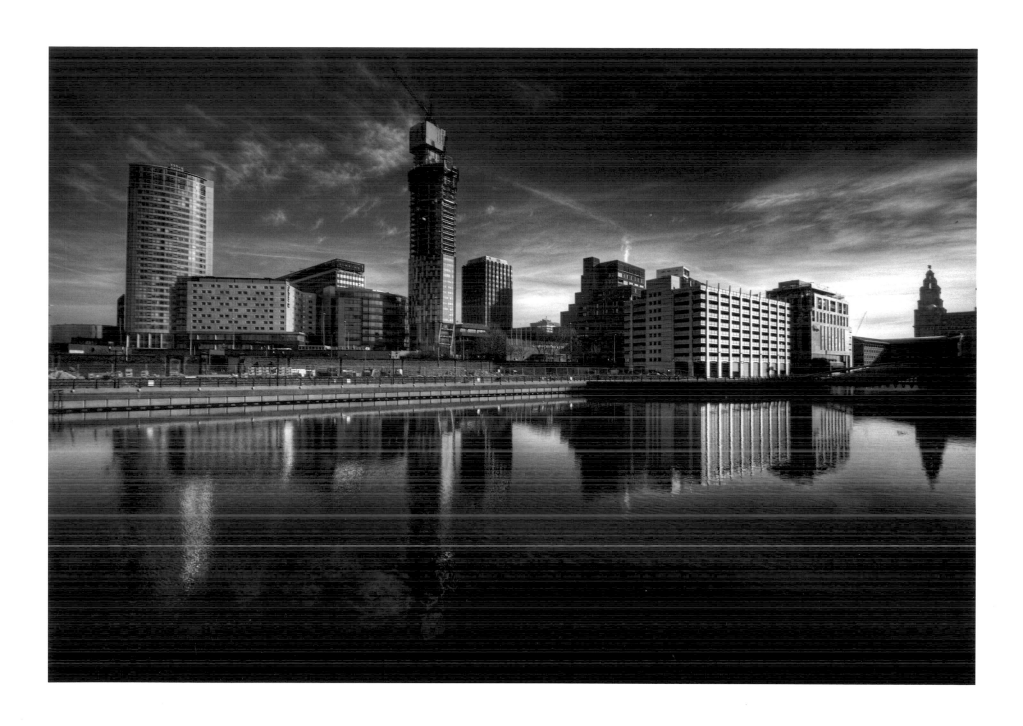

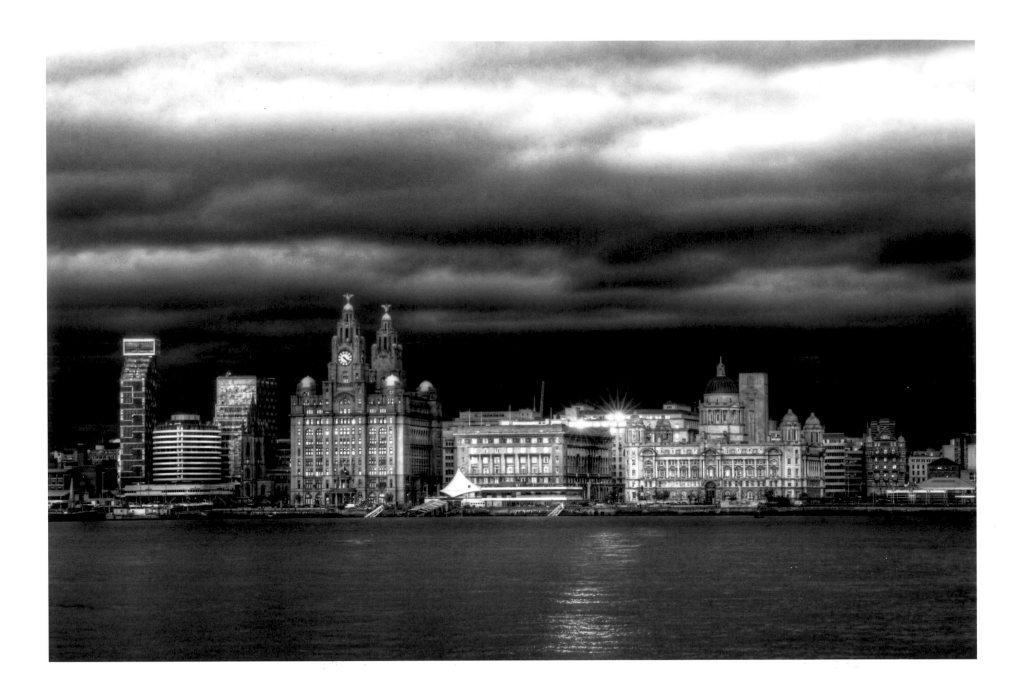

Liverpool skyline on a stormy evening

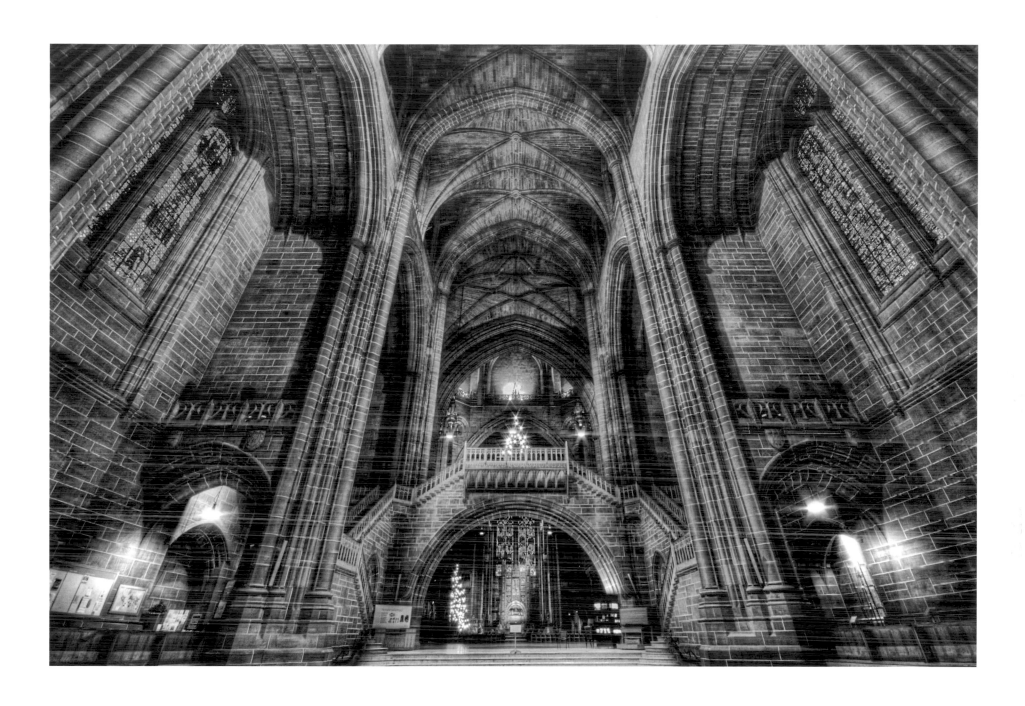

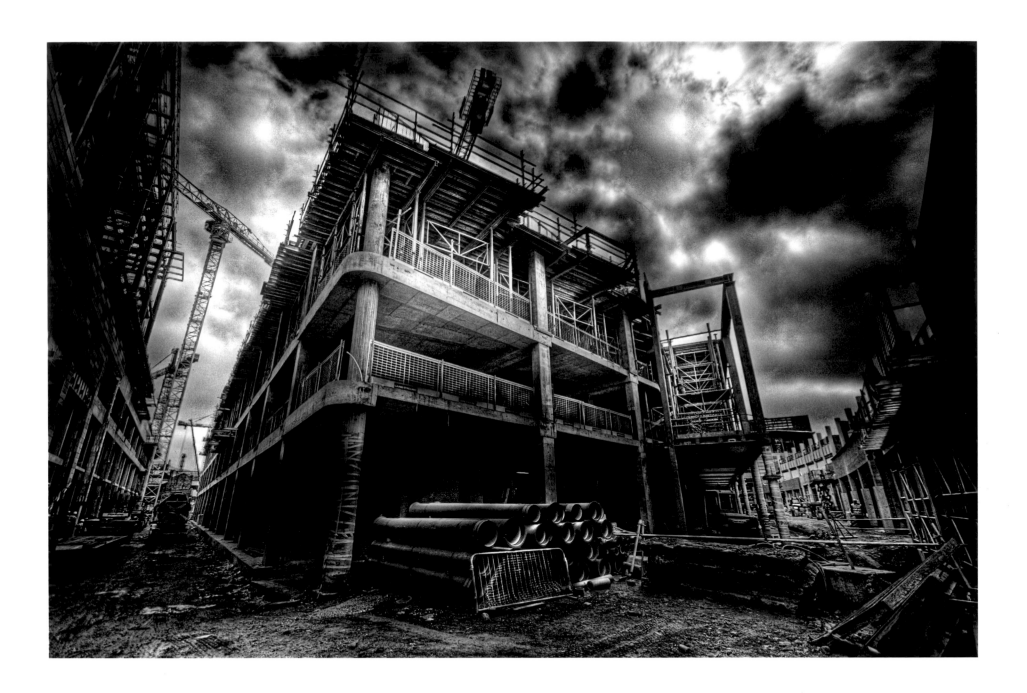

36 South John Street under construction as part of the Paradise Project

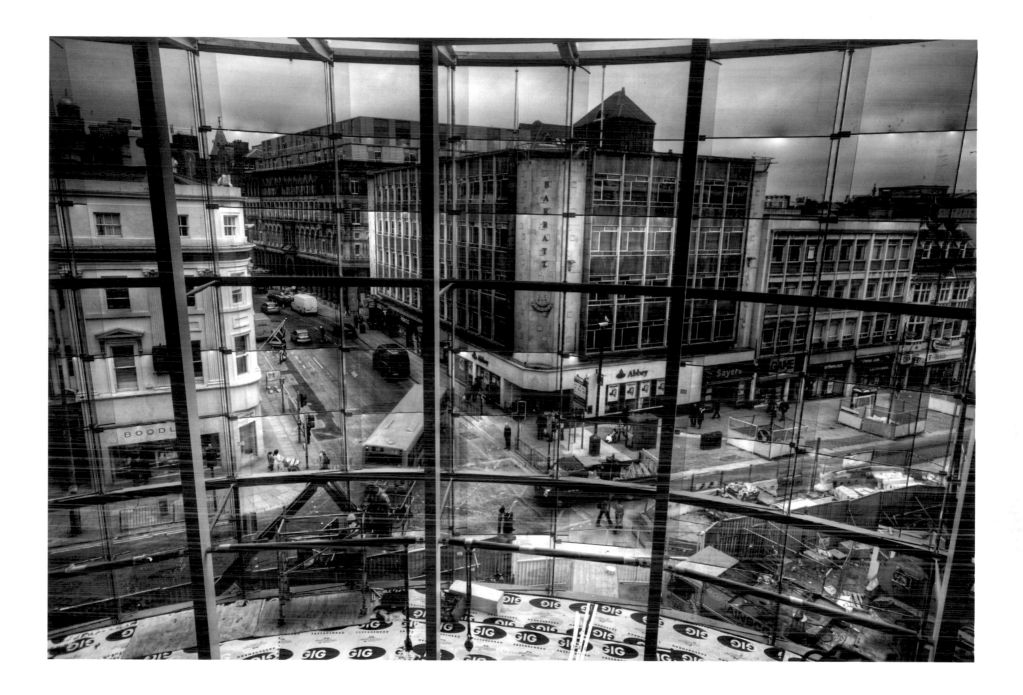

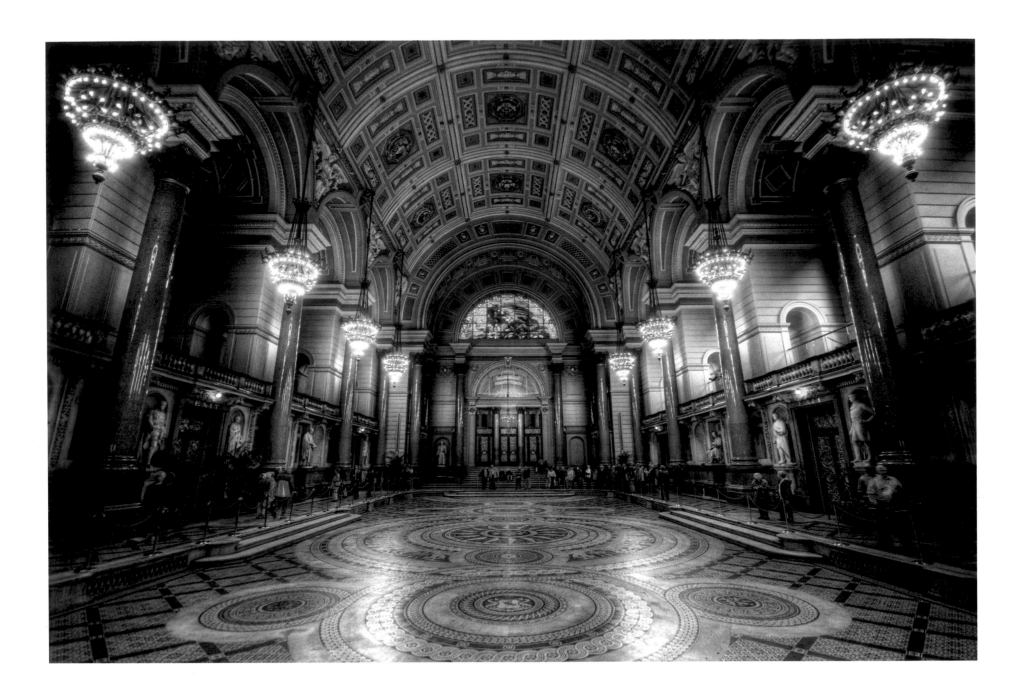

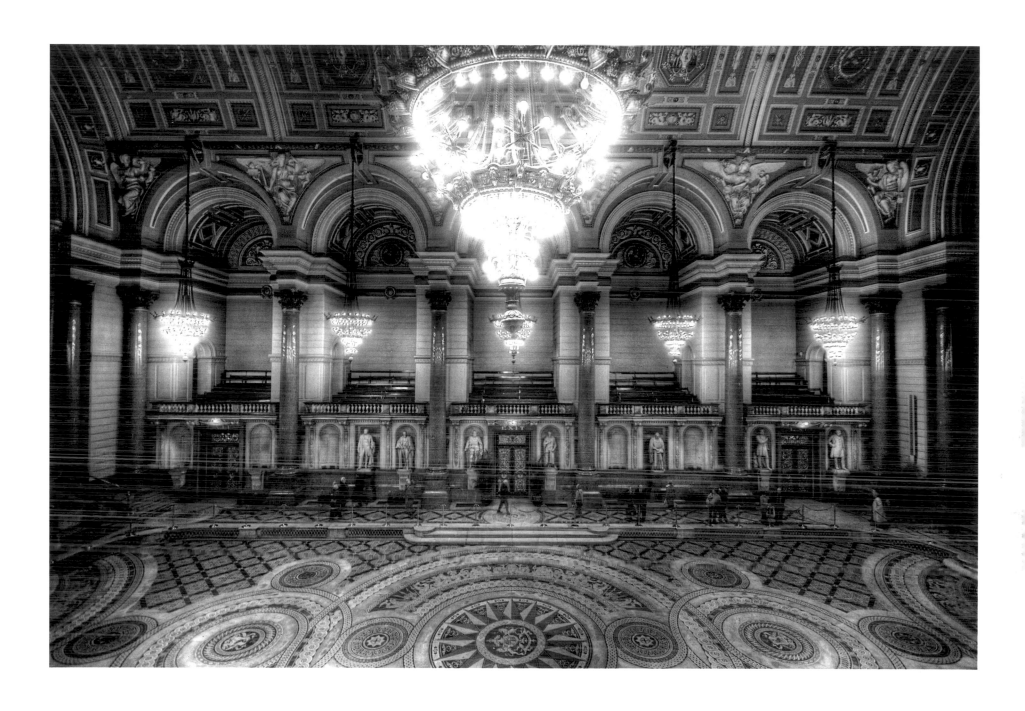

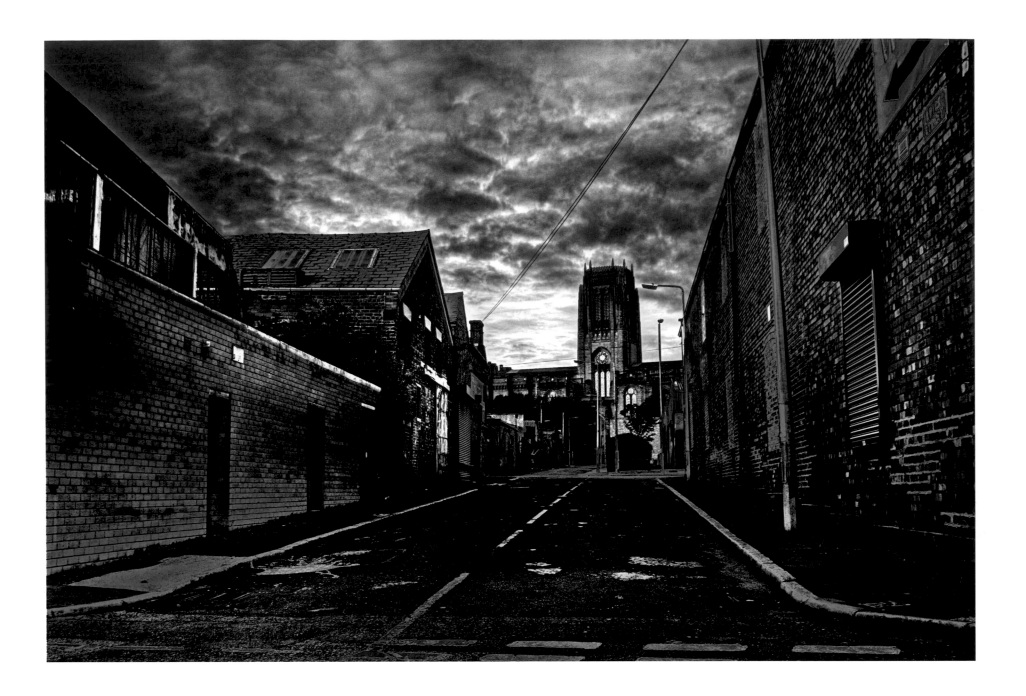

40 Anglican Cathedral as seen from Flint Street

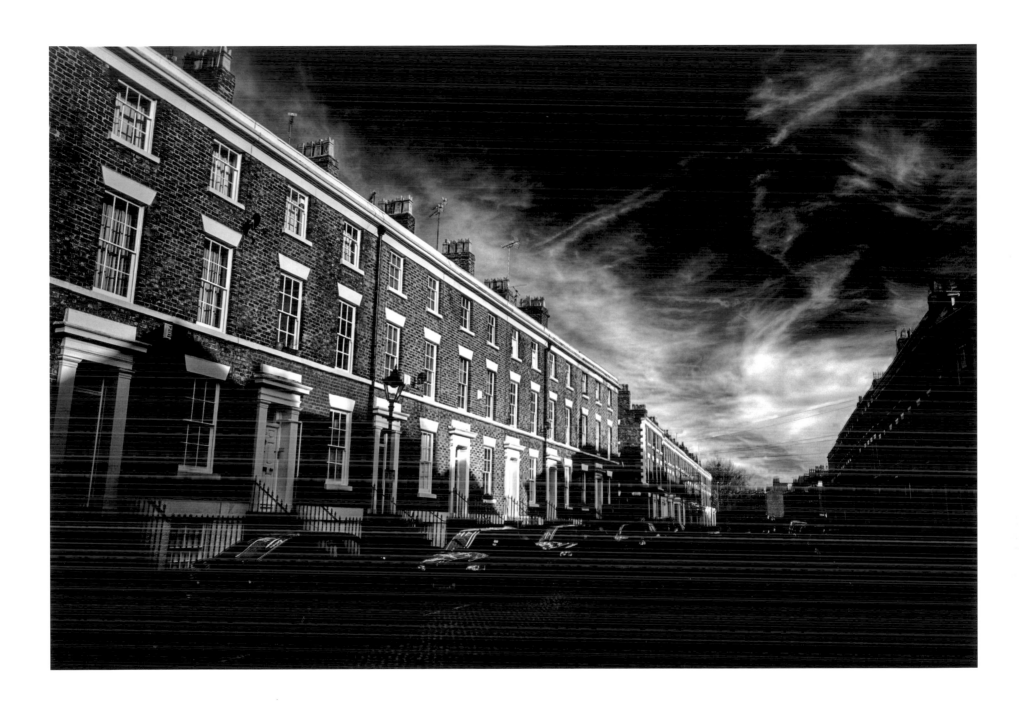

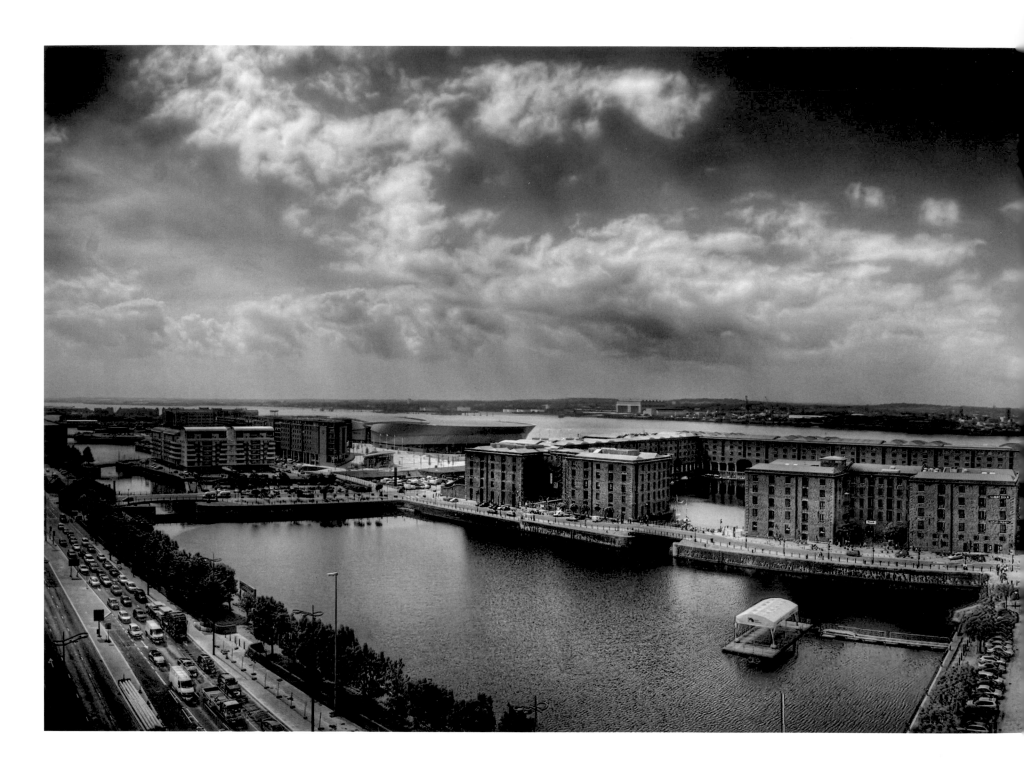

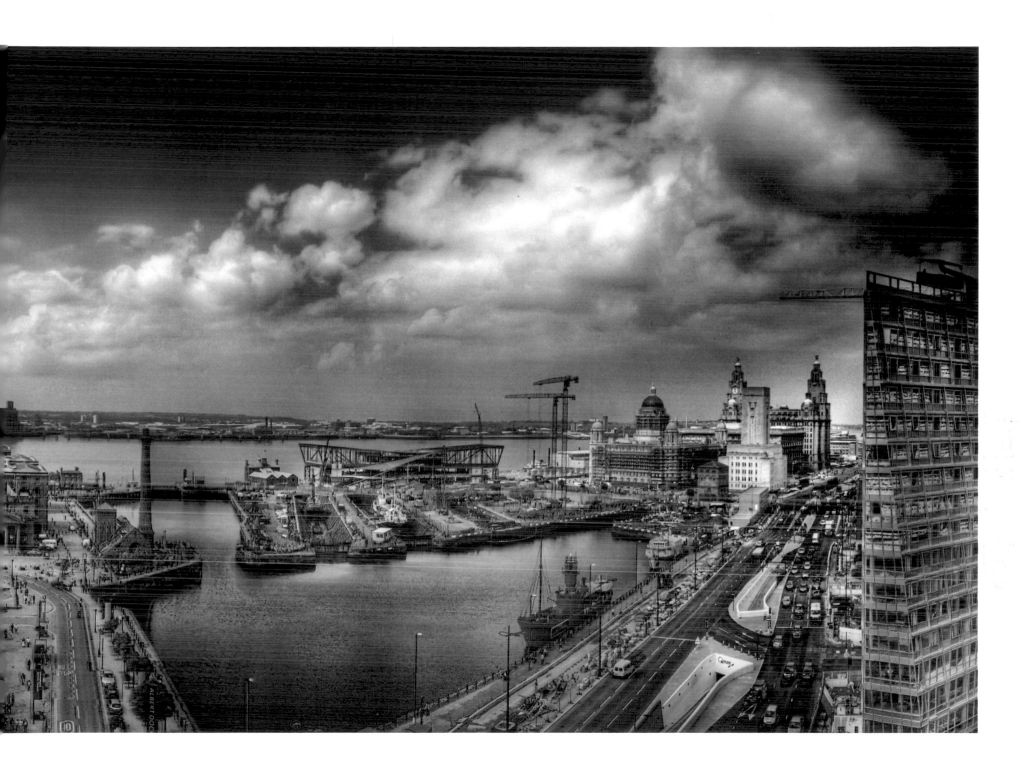

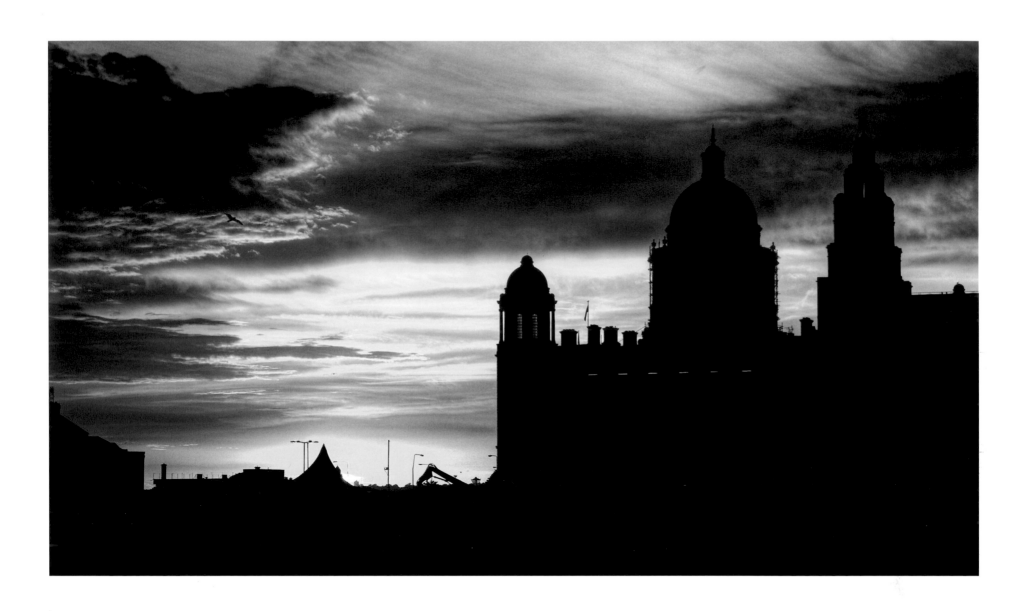

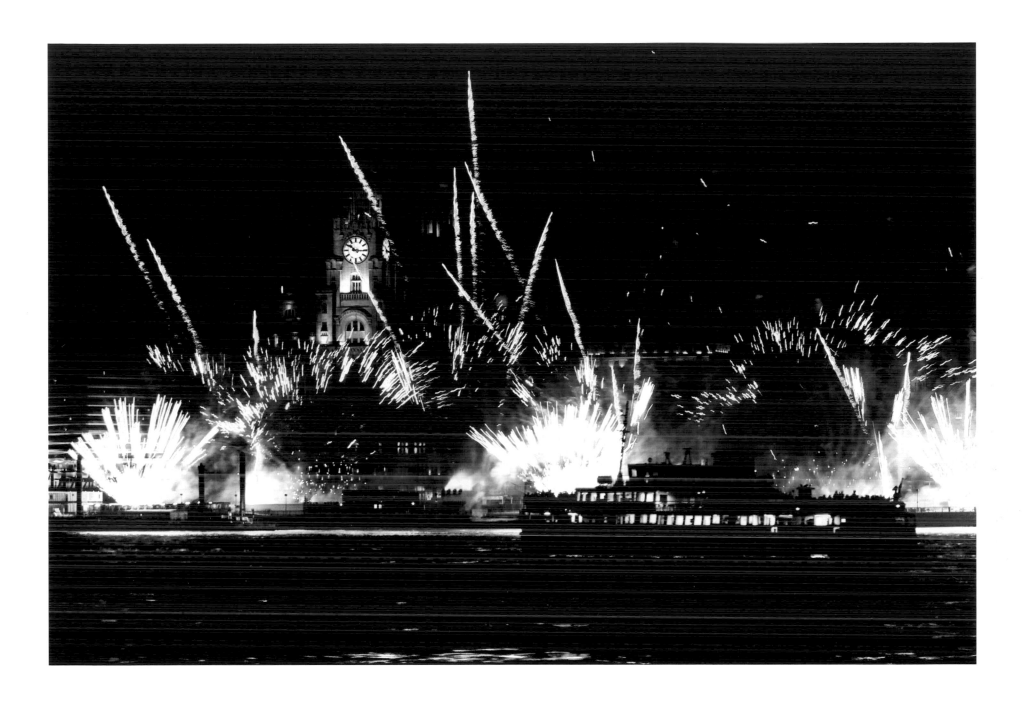

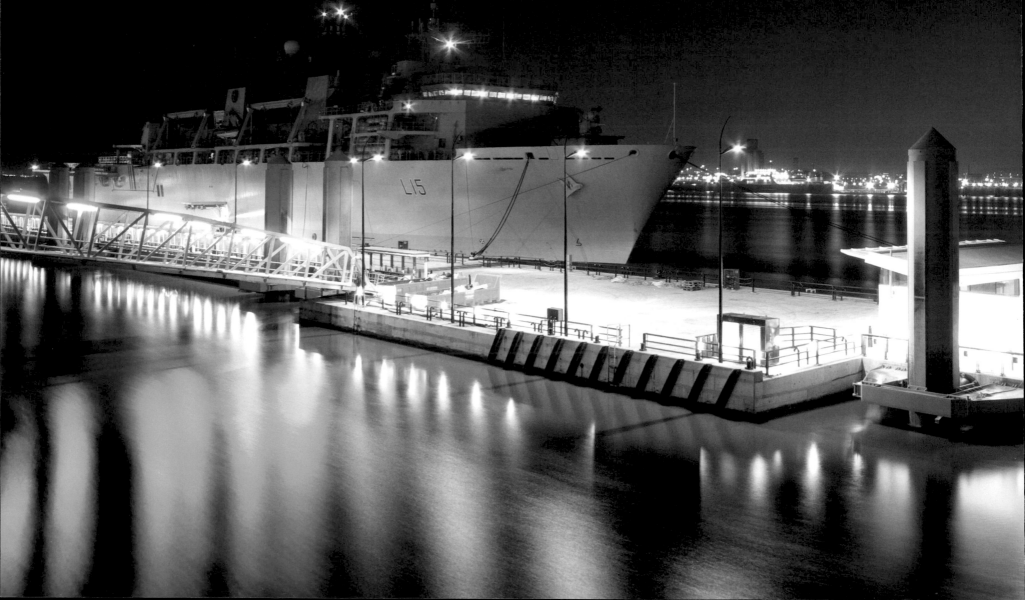

The river

Liverpool is a city built on a river. The architecture and the industries of the past few hundred years have all been shaped by the Mersey. But in recent decades there has been a decline. It's not the huge port that it was and the river is no longer filled with ships. However, with the addition of the cruise liner terminal big ships can return to the Mersey. The *QE2*, for example, looks stunning against the skyline. It's great to once again see such ships here. 2008 welcomed the return of the Tall Ships, a real showcase of how Liverpool may have once looked.

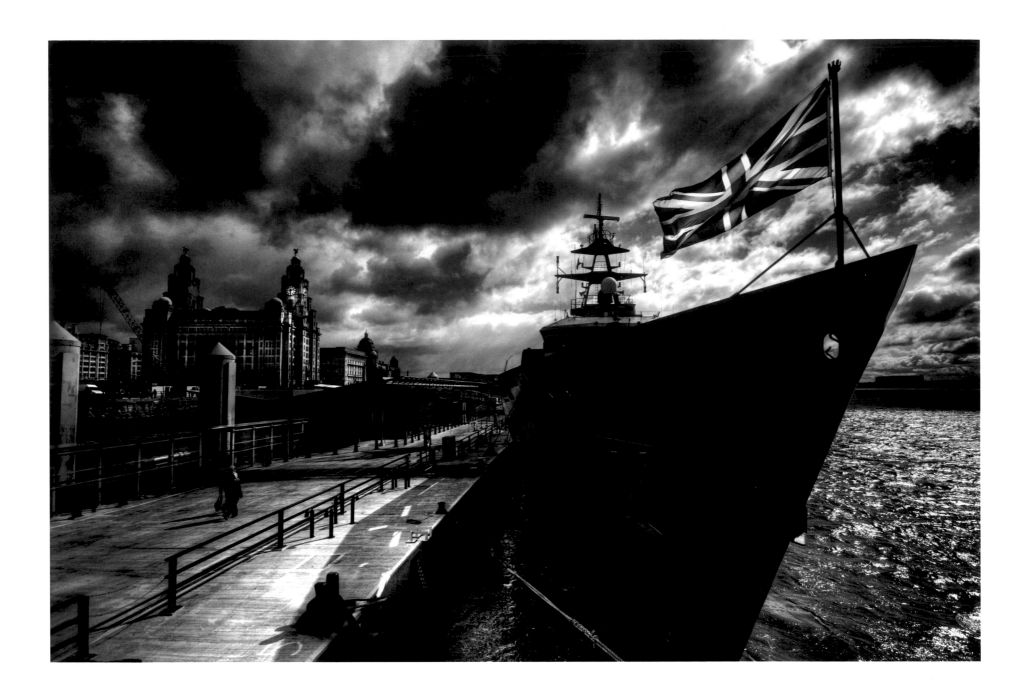

48 *HMS Mersey* docks at the cruise liner terminal

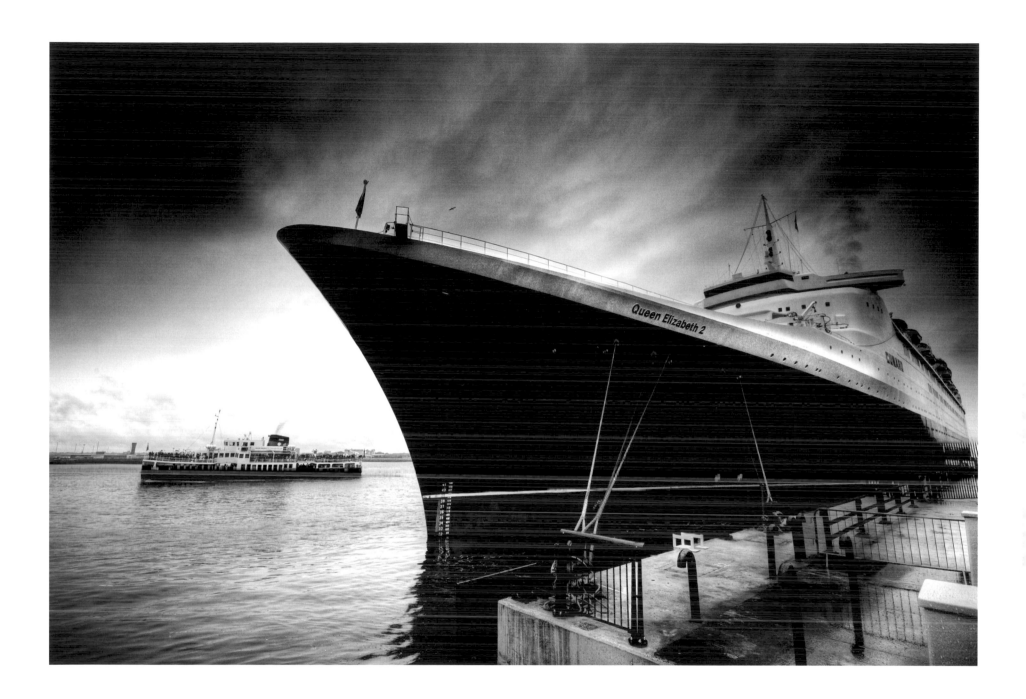

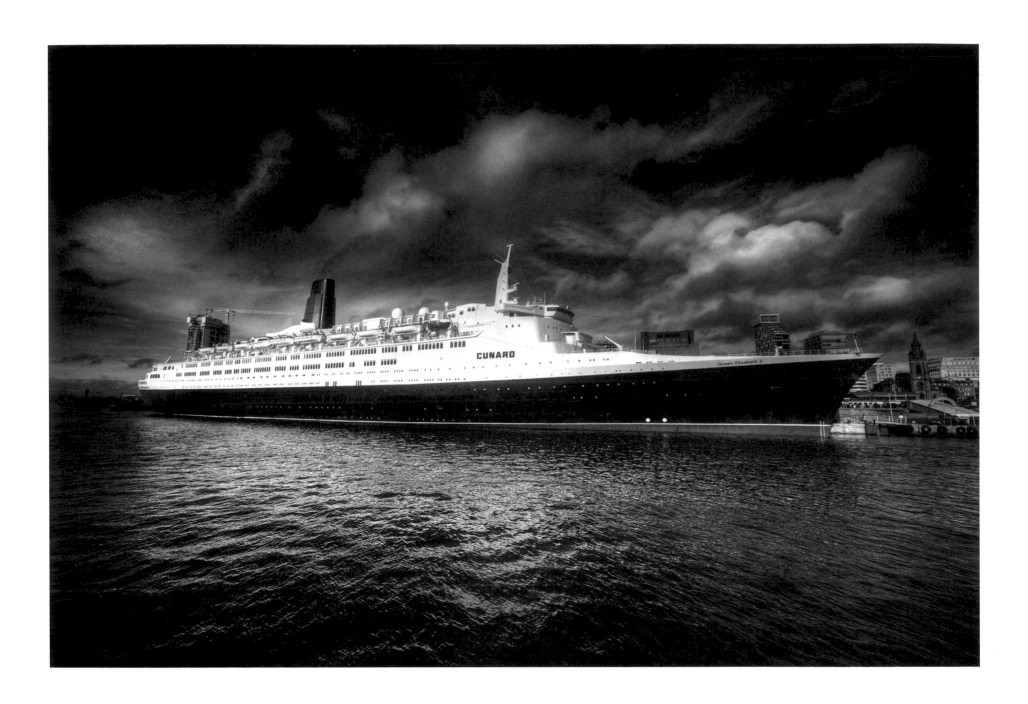

The *QE2* as seen from the ferry

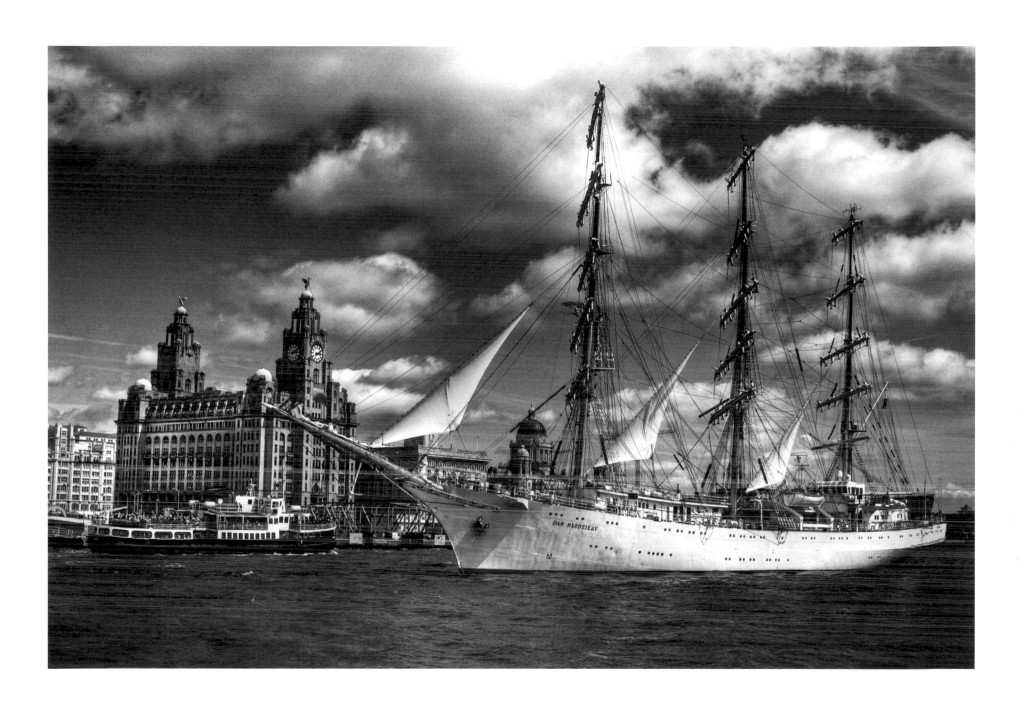

Dar Mlodziezy sails past the Three Graces, Tall Ships 2008

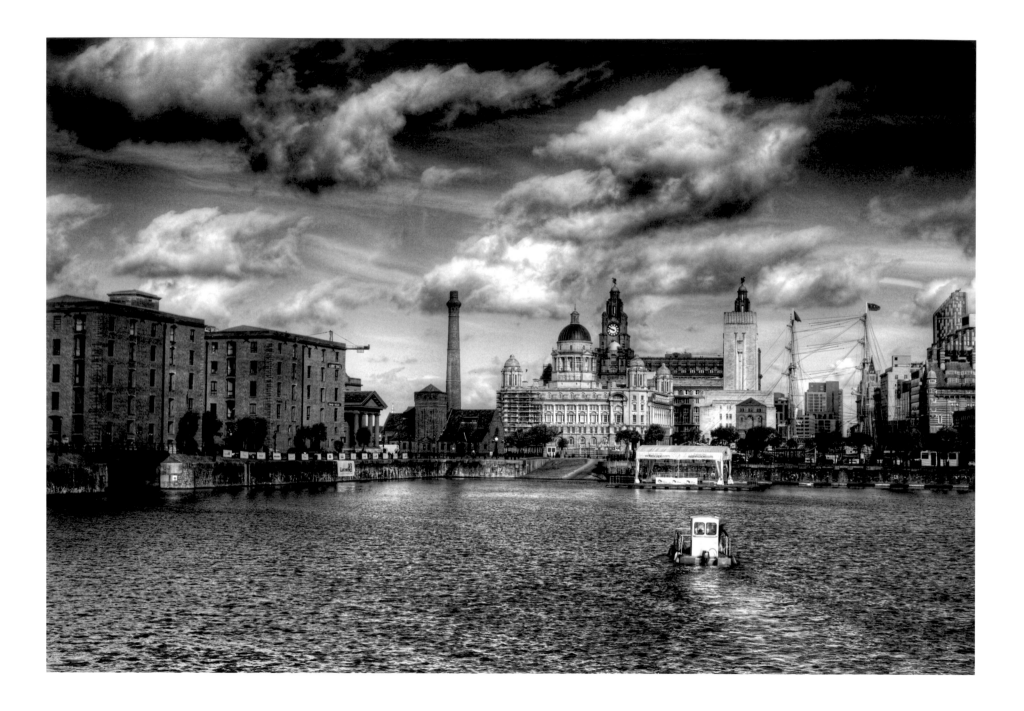

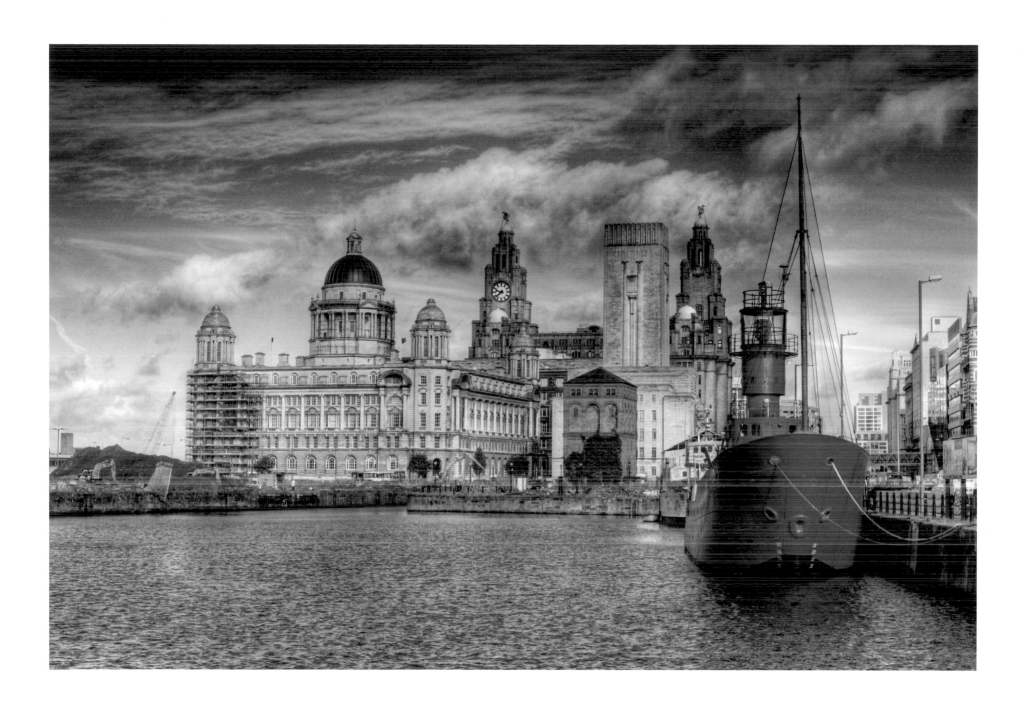

The people

In March 2006 Condoleezza Rice visited Liverpool. The city spoke out against her visit in a way I've never seen. Hope Street was full of people. You just couldn't move. I expect half of Hardman Street was the same but I couldn't see through the crowds. It really was a unique event. The piece about Guantanamo Bay was quite something to see on the steps of the cathedral. I spent hours documenting the event, although most of the time was spent squashed against the railings at the front waiting for that perfect photo. I was waiting for Condoleezza Rice to appear and for the crowd to explode. She never did but there were times when they really did turn up the volume. I hung over the barrier with my camera held out to get the photo of the person with the flag. I can still hear the chants in my mind as clear as the day I was there: 'Condi, Condi, Condi!'

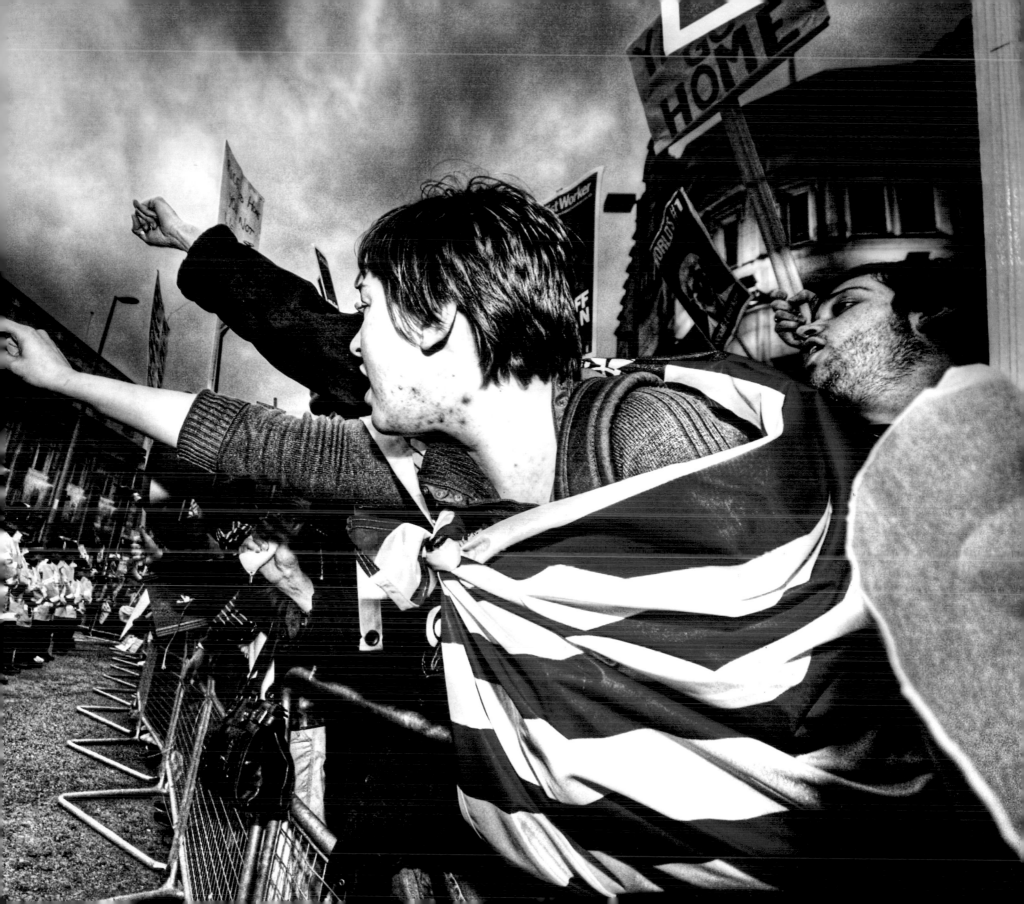

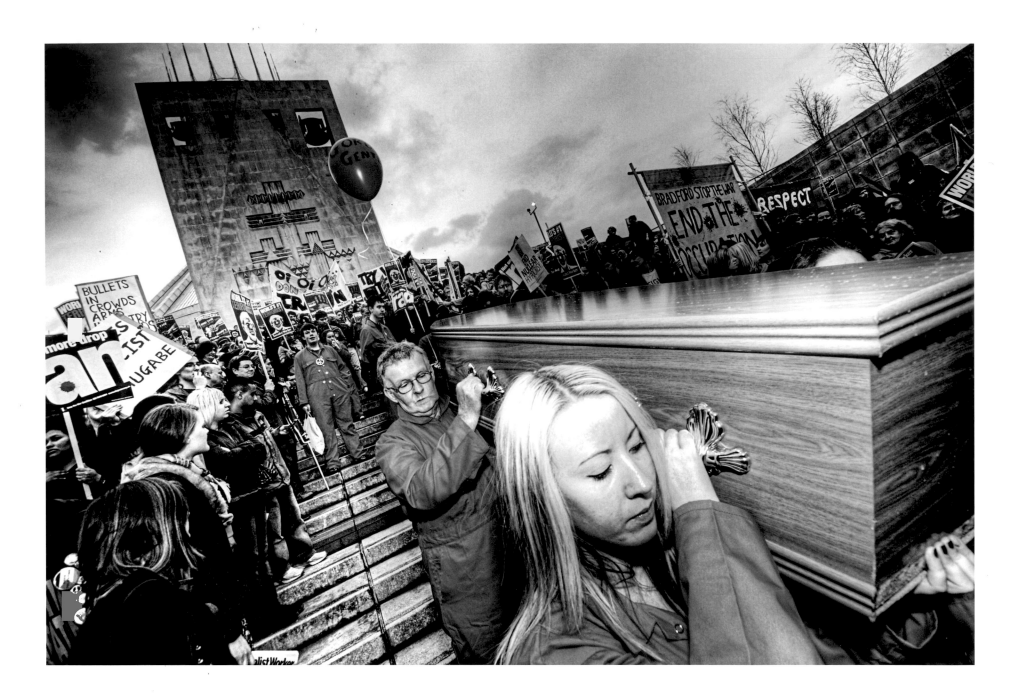

56 Protests against the visit of Condoleezza Rice at the Metropolitan Cathedral

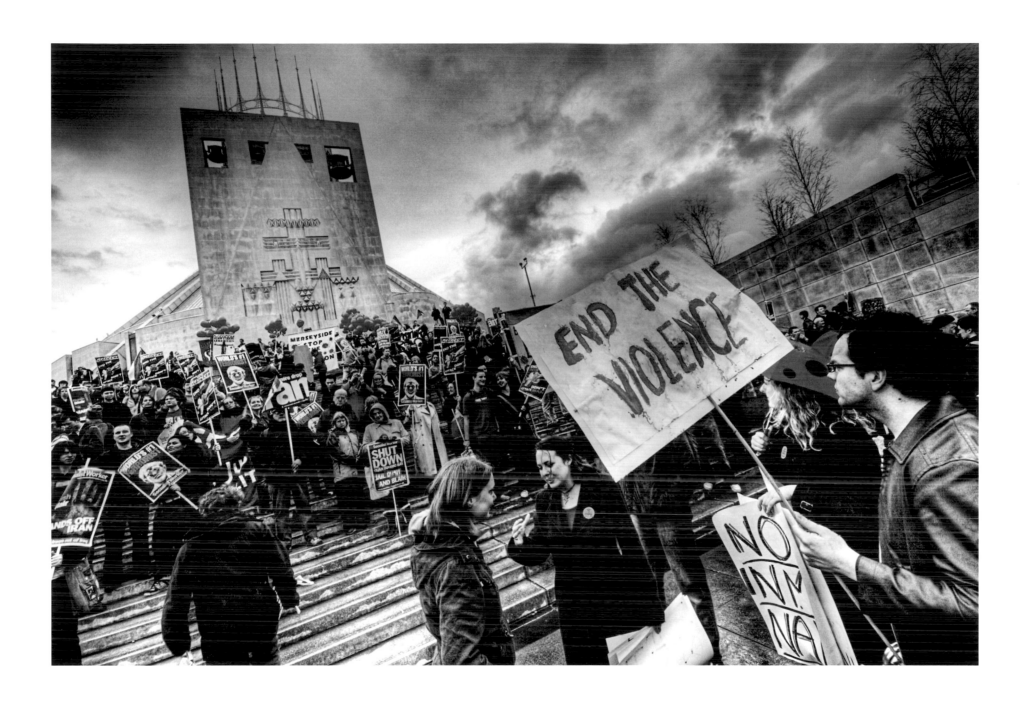

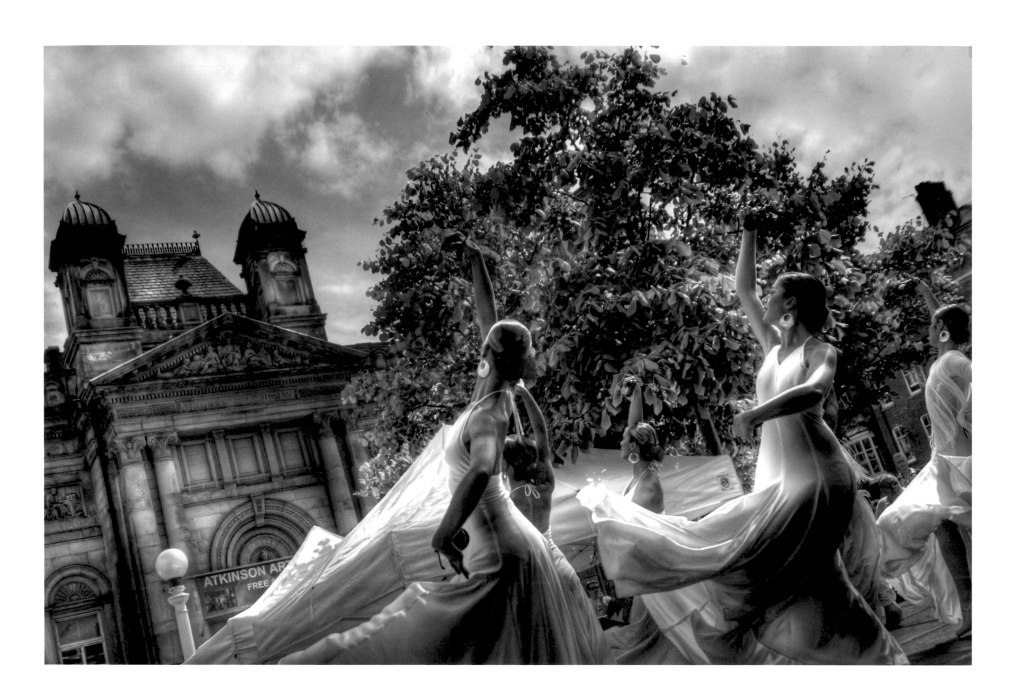

58 Ballet Entredanzas in Southport as part of the Brouhaha Festival

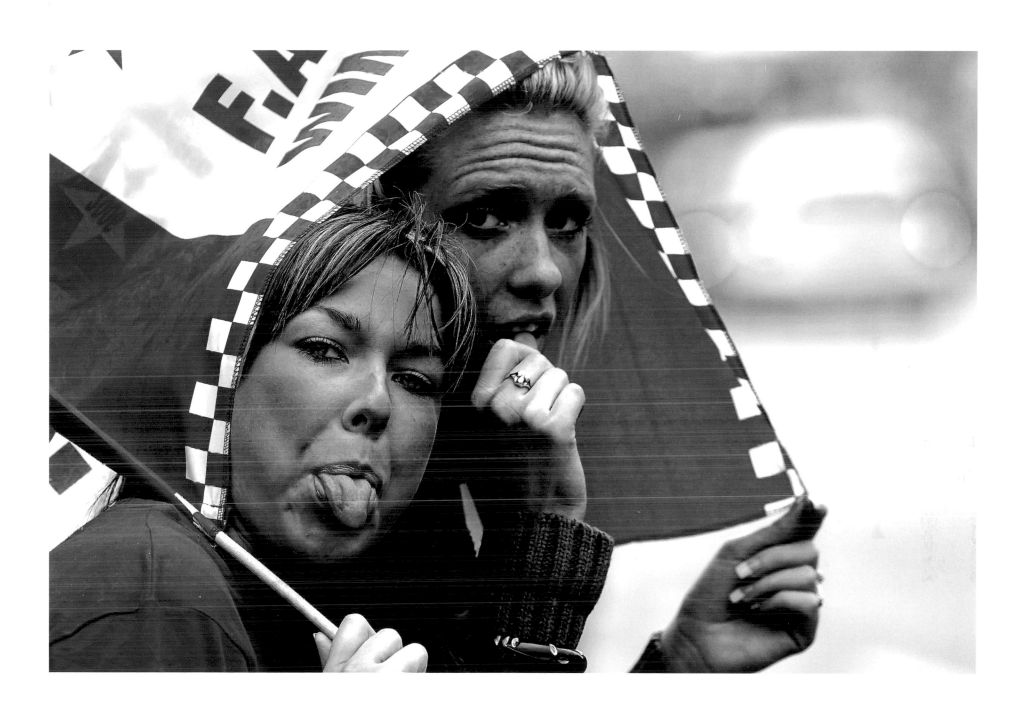

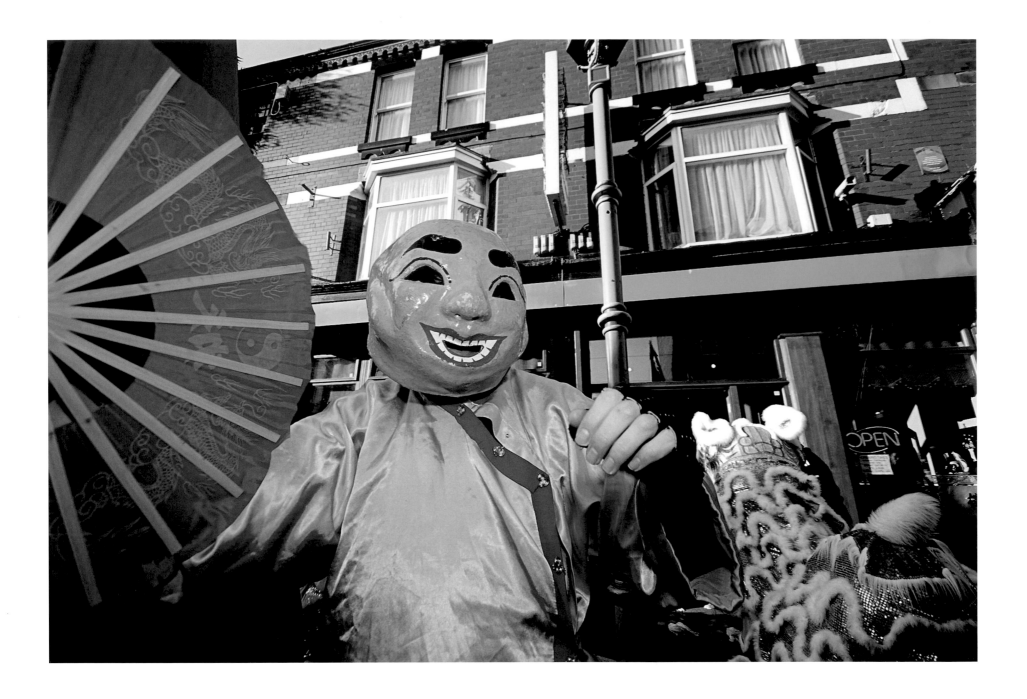

Chinese New Year, 2006

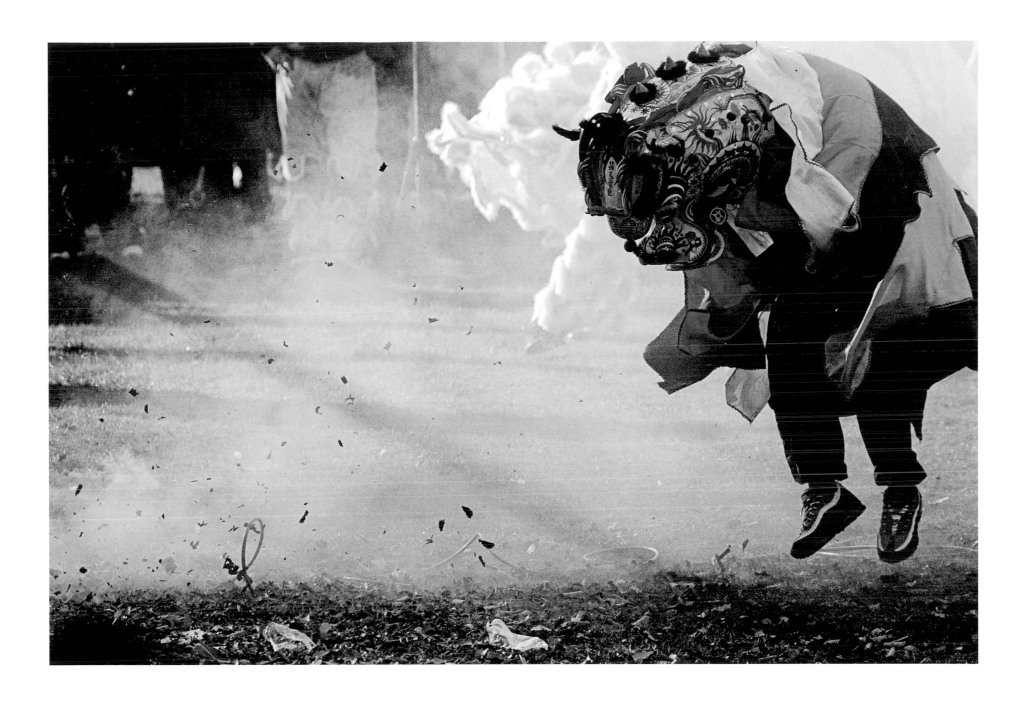

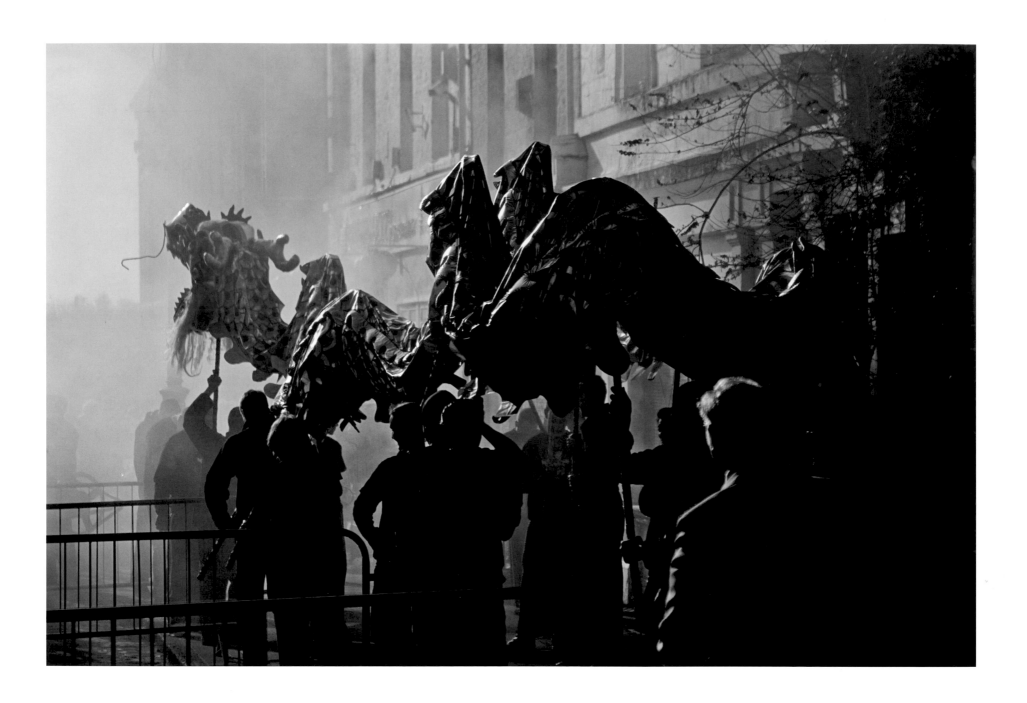

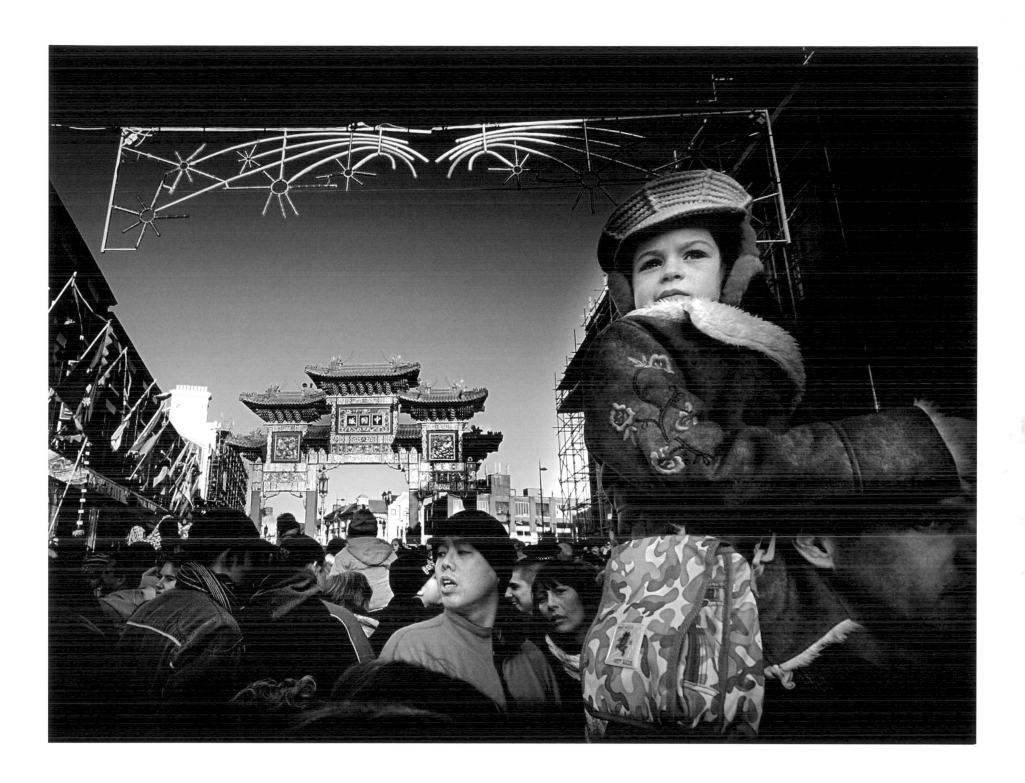

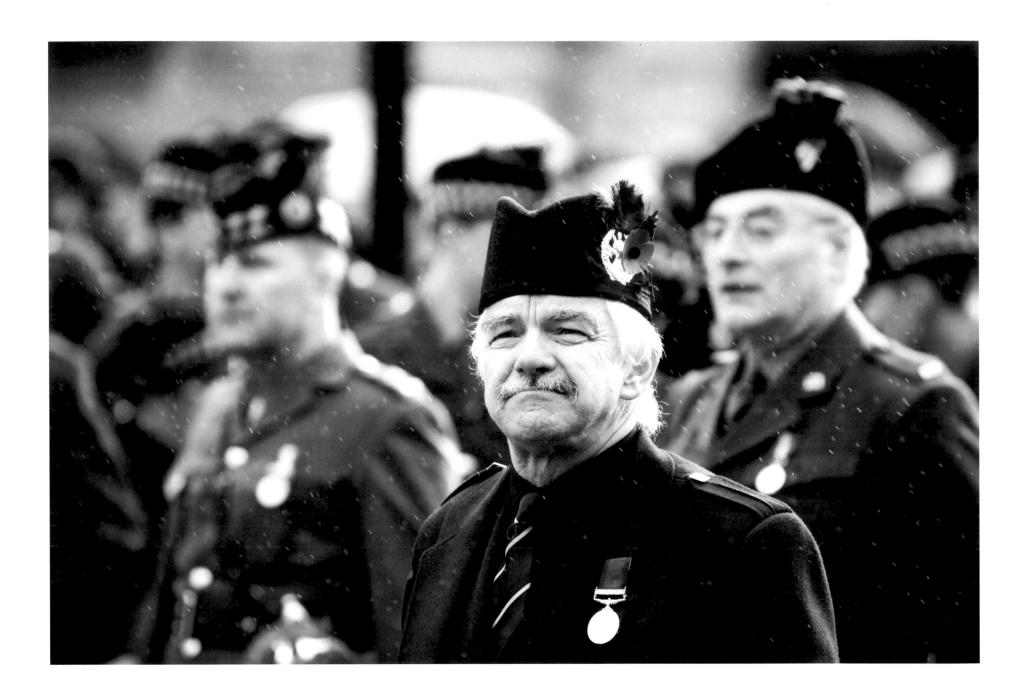

Remembrance Sunday, 2007

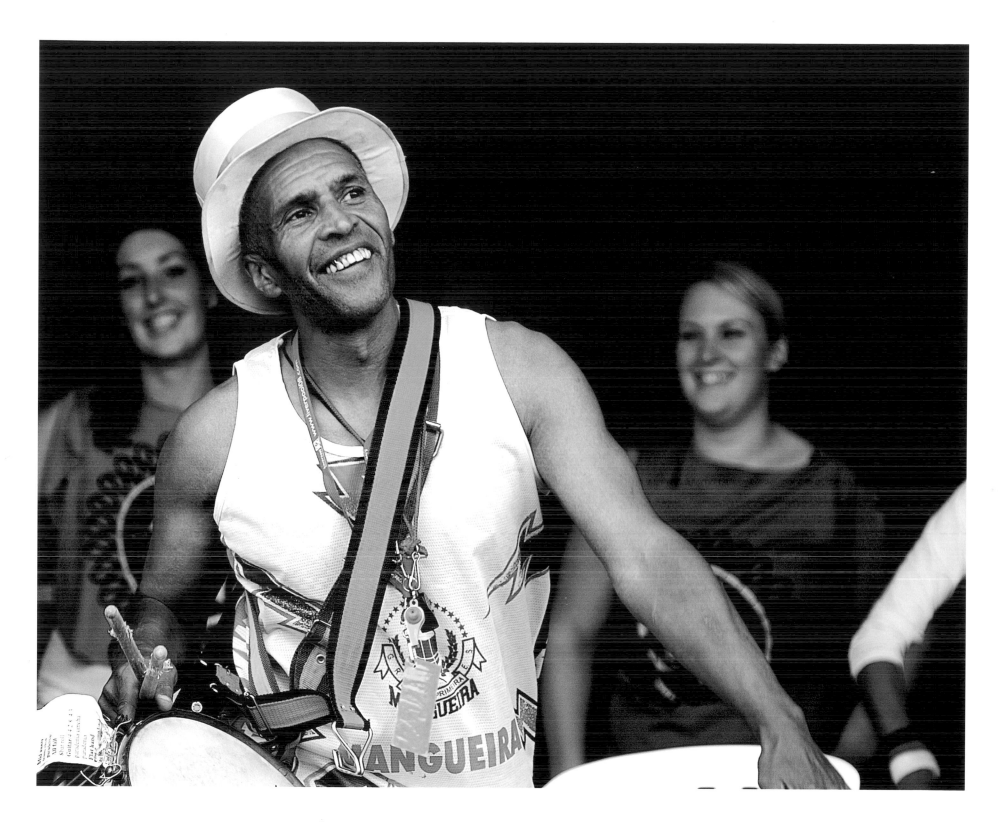

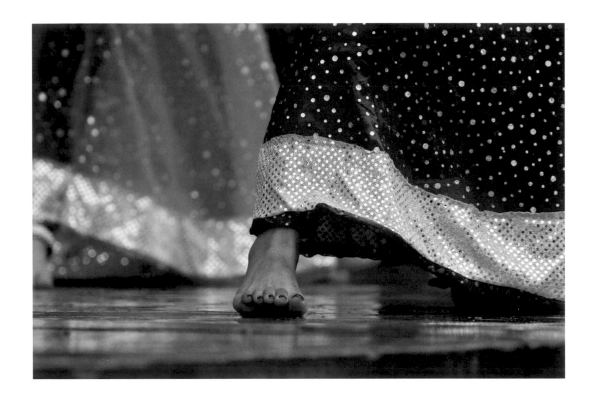

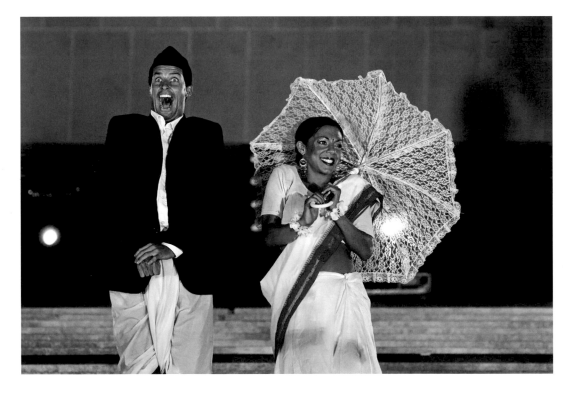

66 TOP: Bollywood dancing helps re-open St George's Hall, 2007 BOTTOM: Bollywood dancing on the steps of the Metropolitan Cathedral

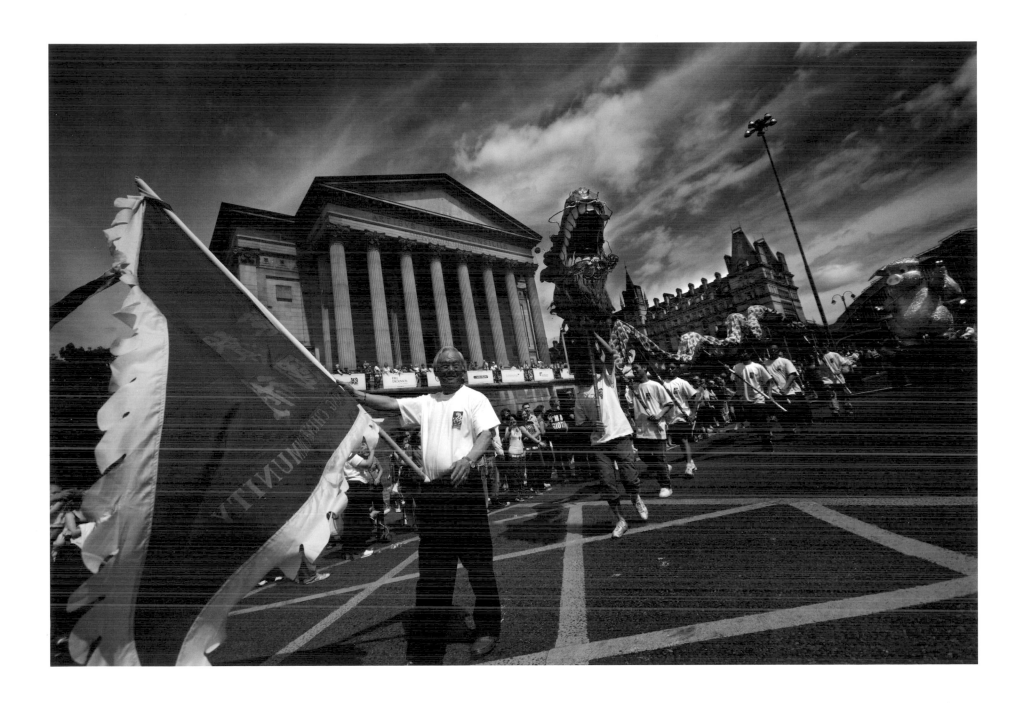

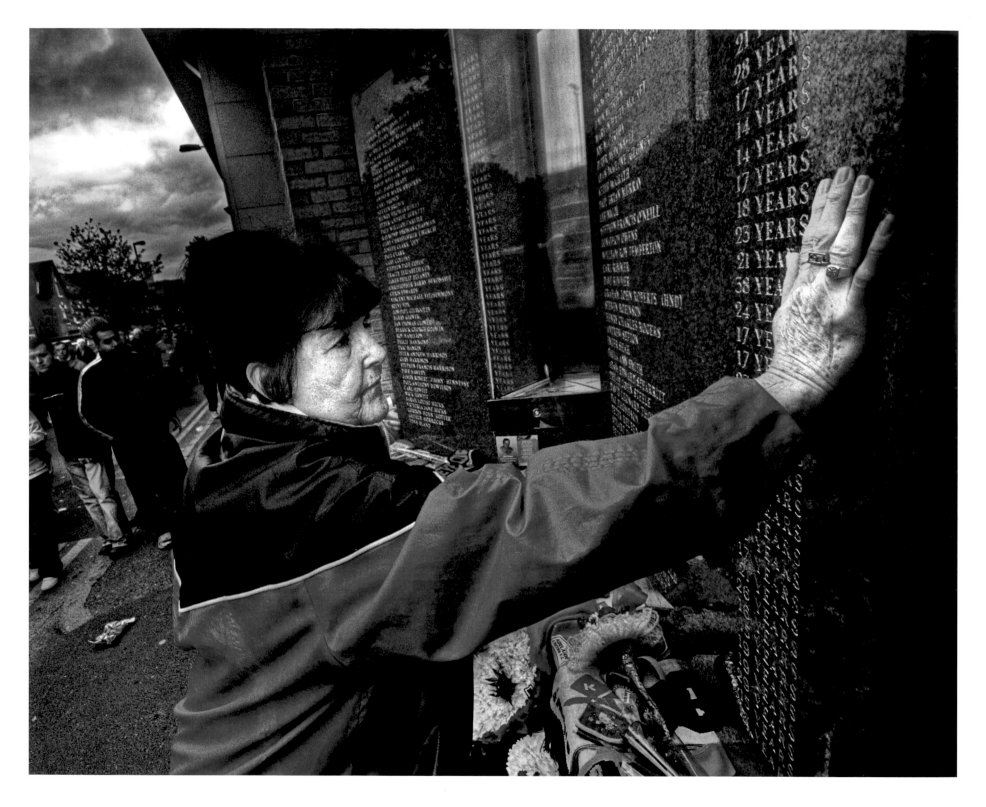

68 A Liverpool fan touches the wall by the Eternal Flame to remember the 96 who died at Hillsborough

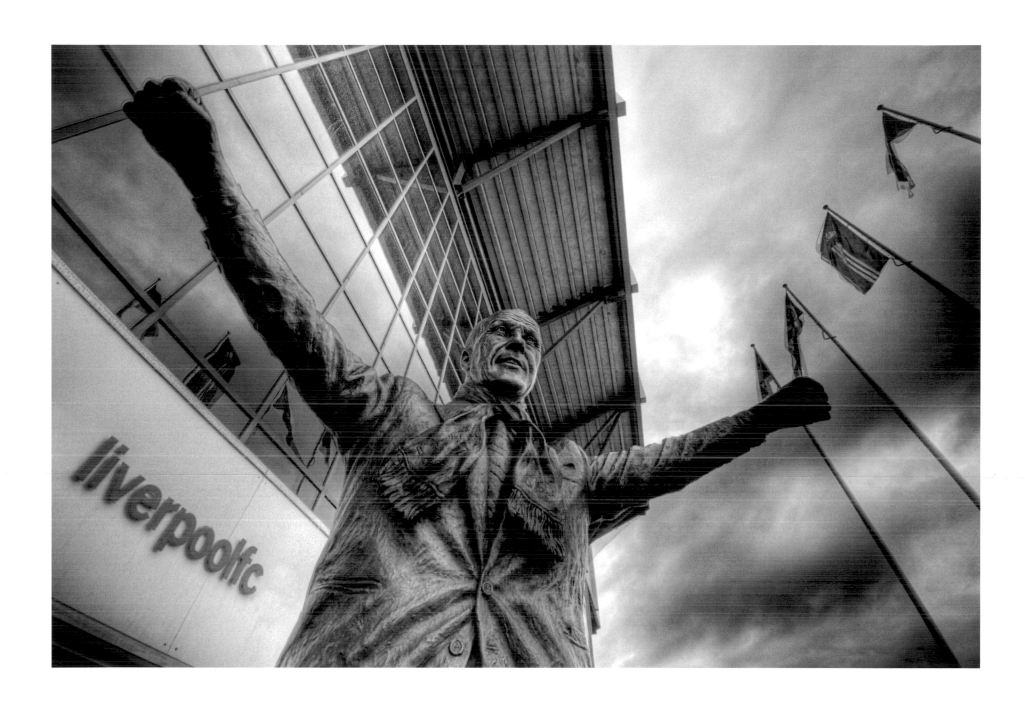

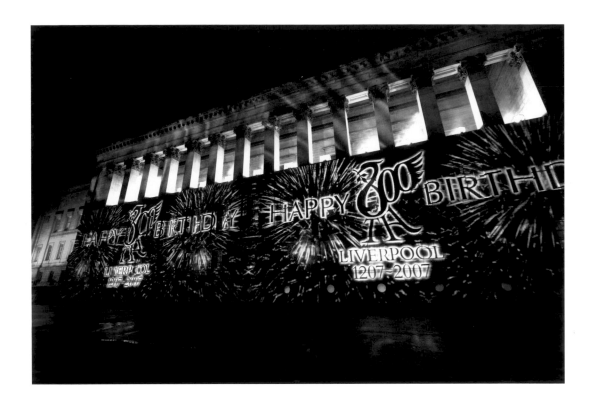

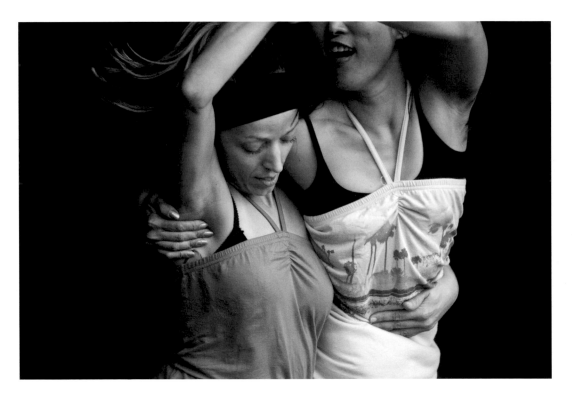

70 TOP: Son et lumière show as part of the St George's Hall re-opening BOTTOM: Performers as part of the Brouhaha Festival

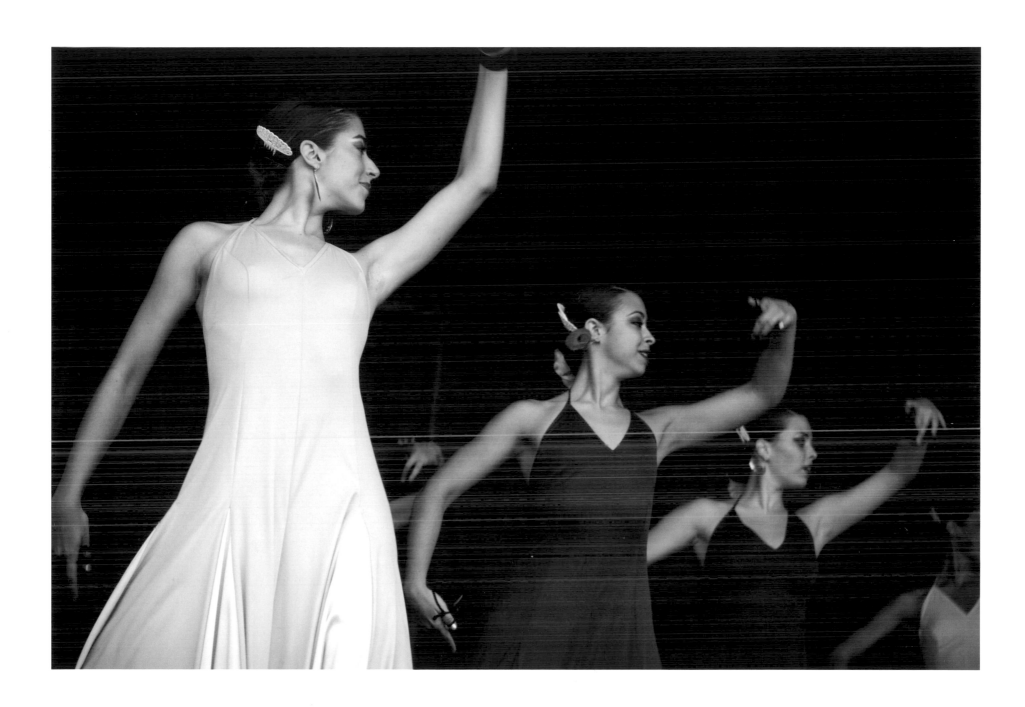

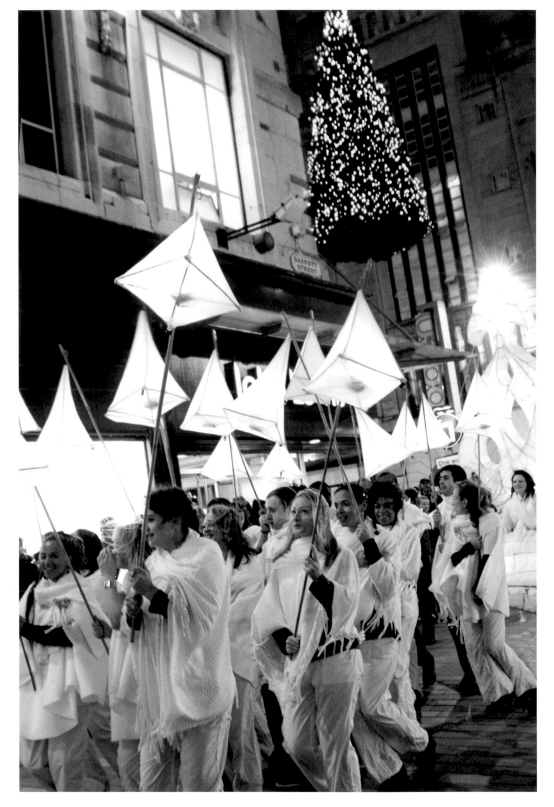

Start of Christmas celebrations in town, 2006

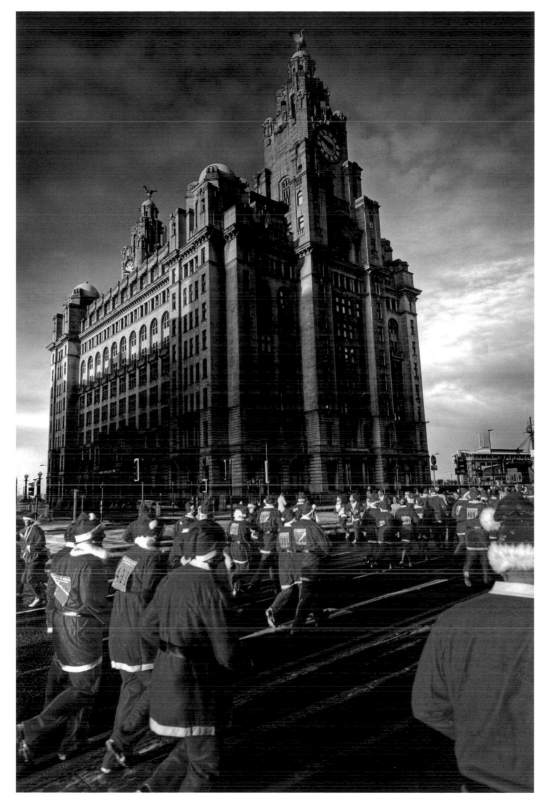

Over 5,000 people running down the Strand for the Santa Dash, 2006 **73**

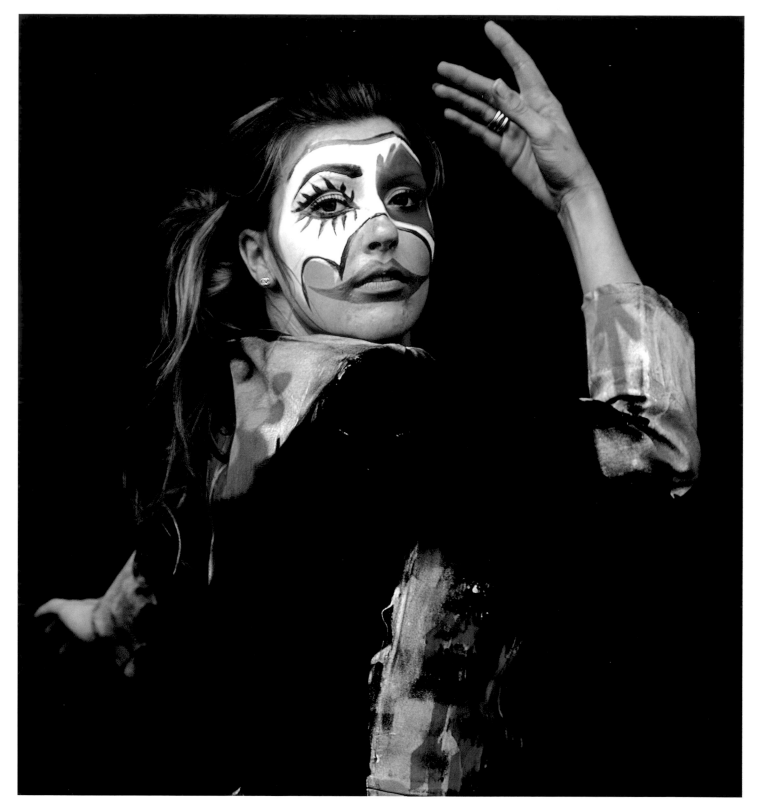

74 A performer in the Brouhaha Festival

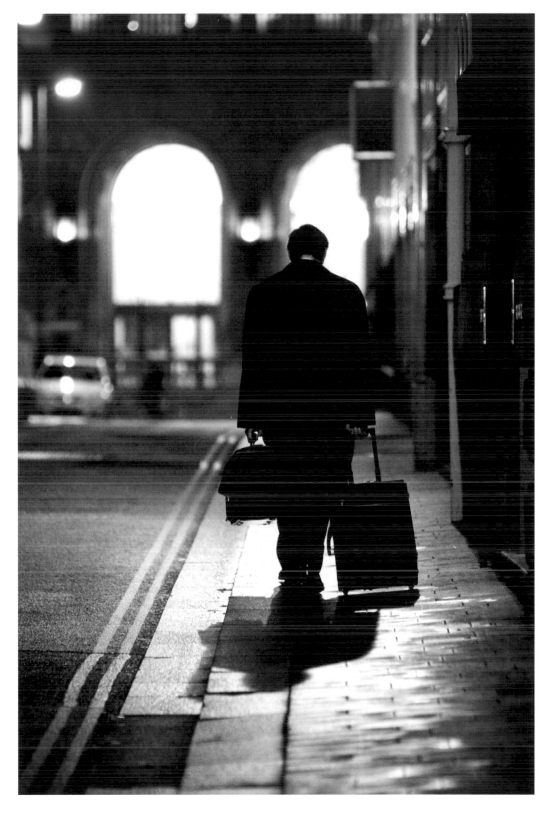

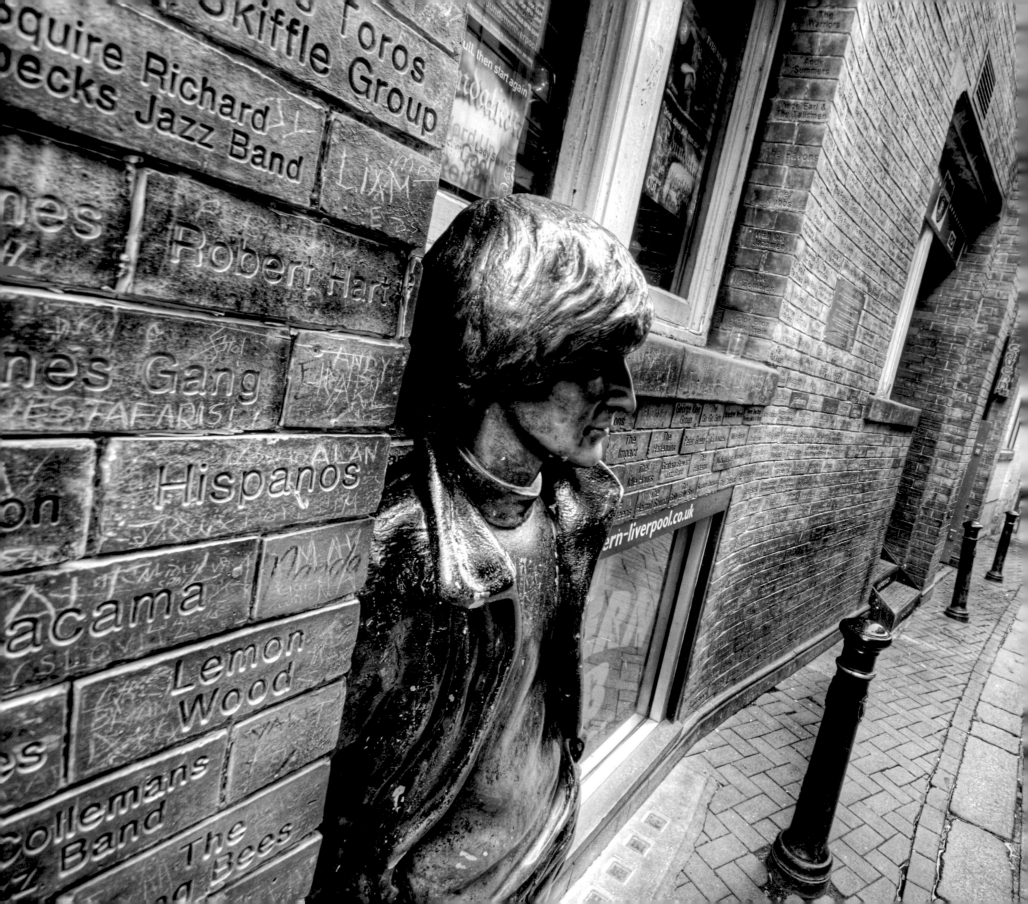

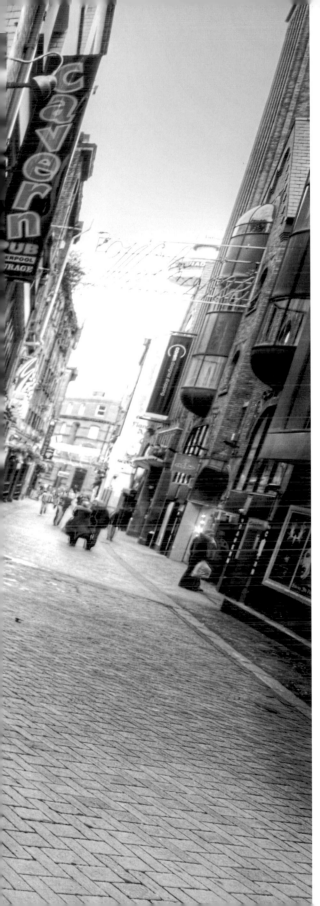

The music

Music is as much a part of Liverpool as the Mersey is. The Beatles, The Zutons, The Lightning Seeds, The Wombats, Shack and Sense of Sound to name a few. We have a huge variety of musical talent here from rap to gospel choirs to indie to experimental electronic. If you can't find something you like you're probably not looking hard enough. The newly constructed Echo Arena is pulling in larger names and bigger audiences. Liverpool was recently named the most musical city in the UK too, and it clearly shows. The Mathew Street Festival is back on. We have Liverpool Music Week, Liverpool Sound City, Cream and the wonderful Philharmonic Orchestra. Even without all those names and brands we still have a huge pool of local talent who gig around the city in their spare time.

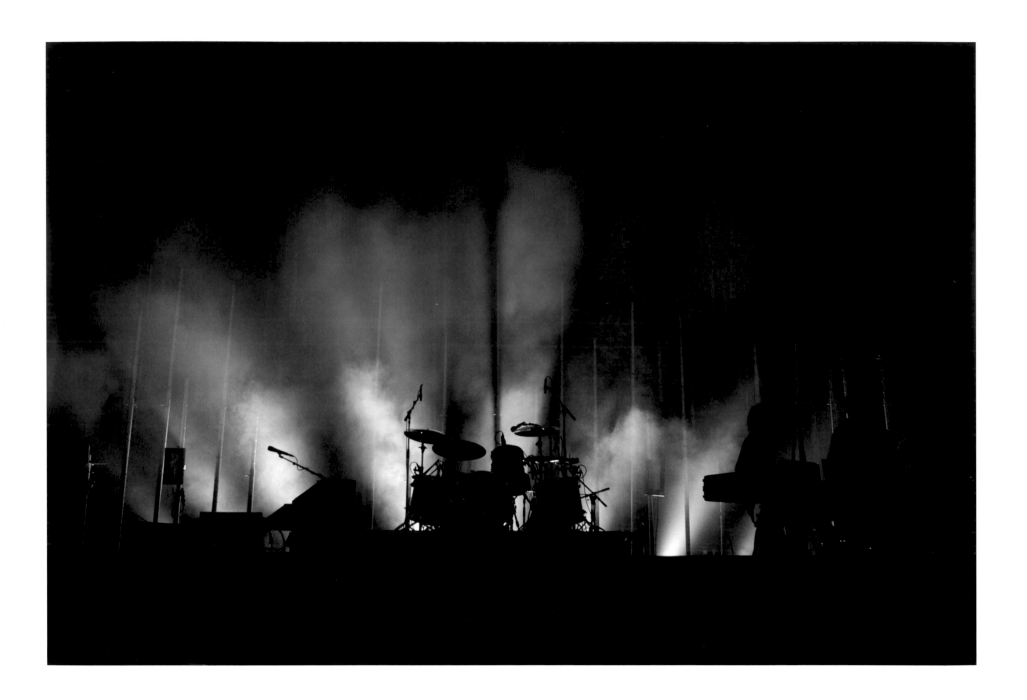

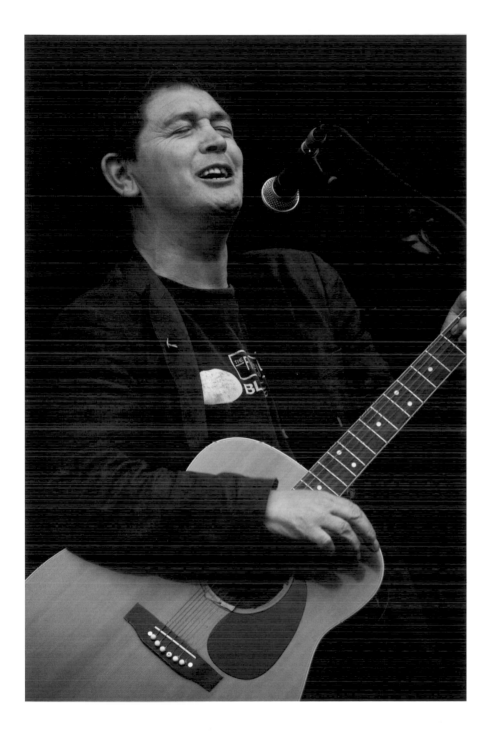

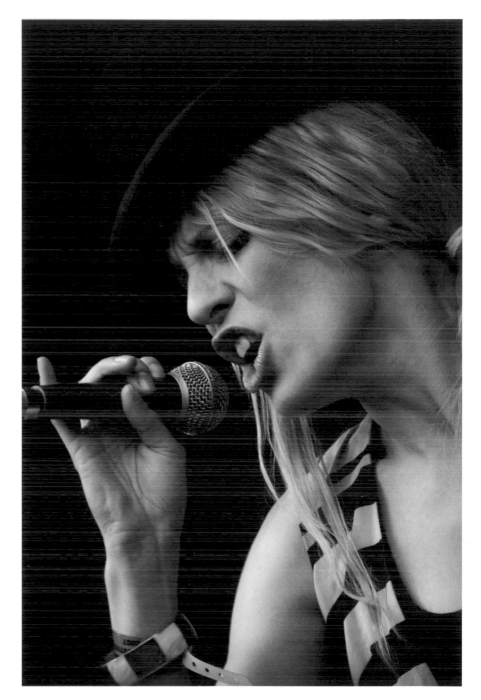

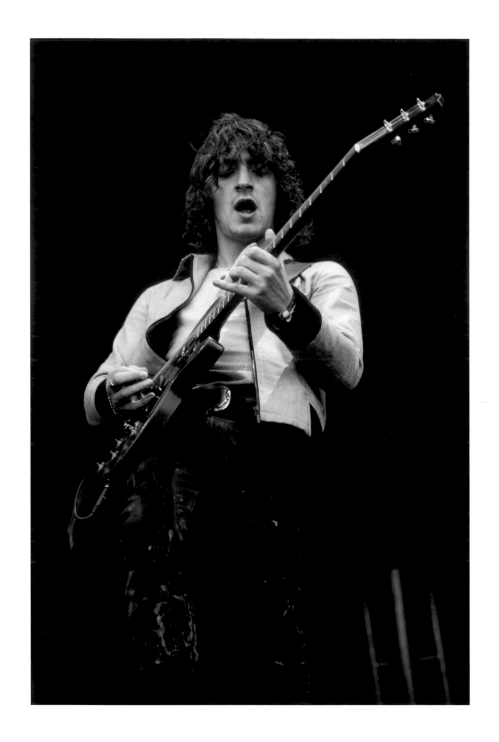

LEFT: The Zutons playing at Knowsley Music Festival RIGHT: Liverpool Music Week, 2006

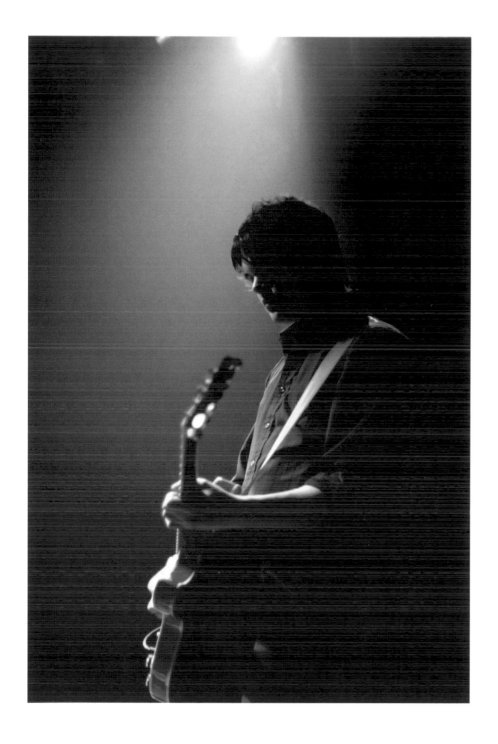

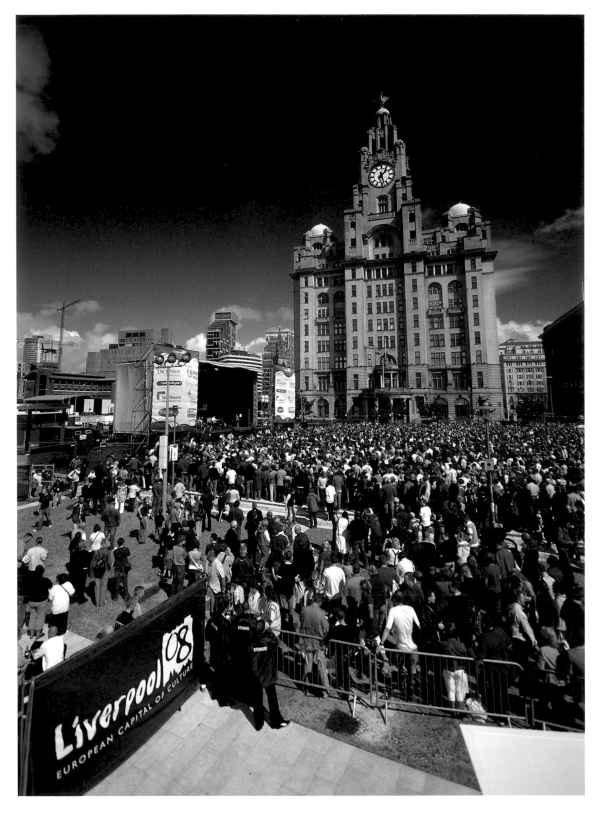

82 Mathew Street Festival, 2006

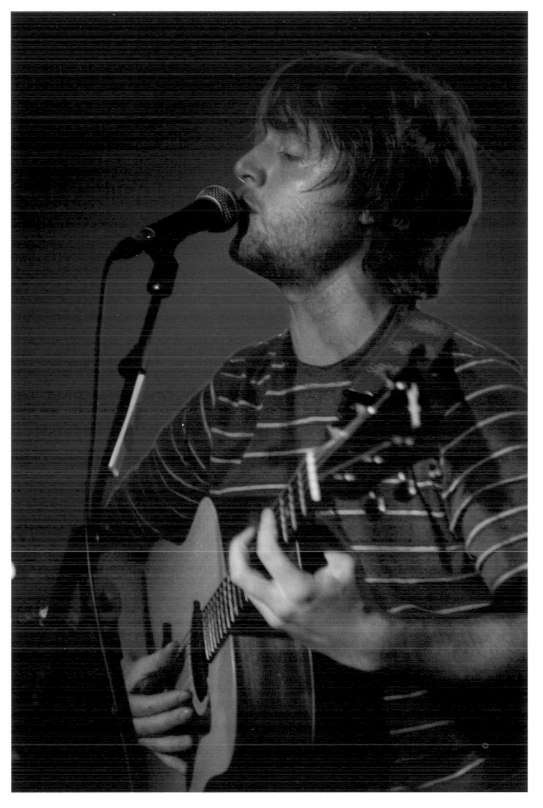

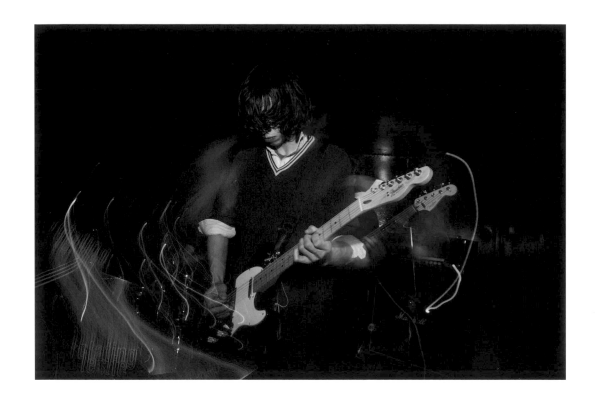

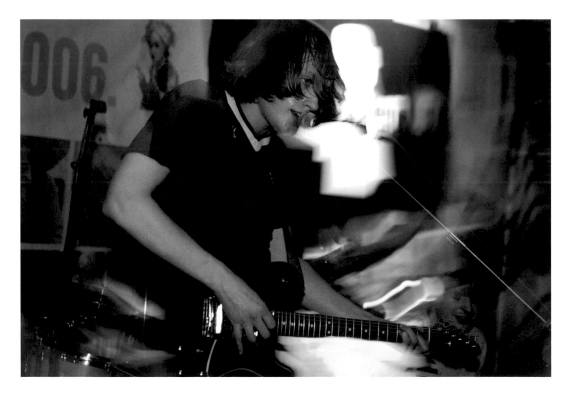

84 TOP: Rotating Leslie at Magnet BOTTOM: Liverpool Music Week, 2006

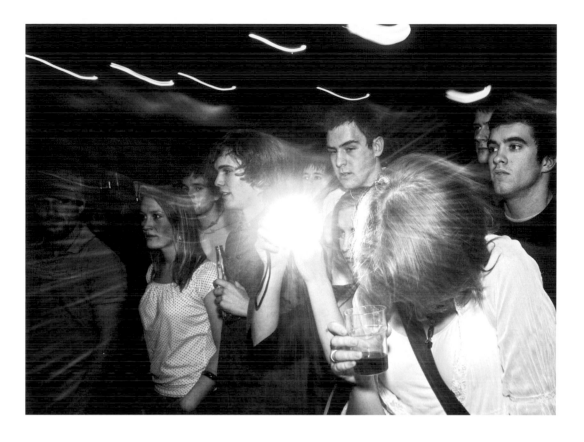

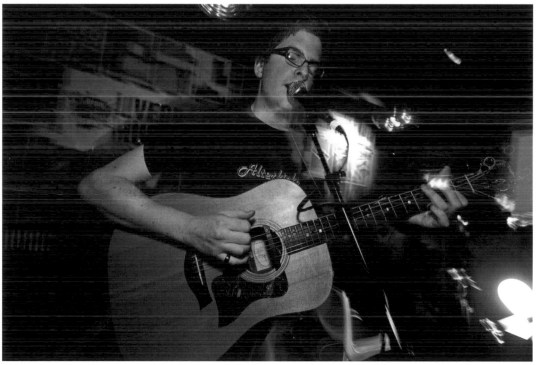

TOP: Liverpool Music Week, 2006 BOTTOM: John Smith at Liverpool Music Week, 2006 **85**

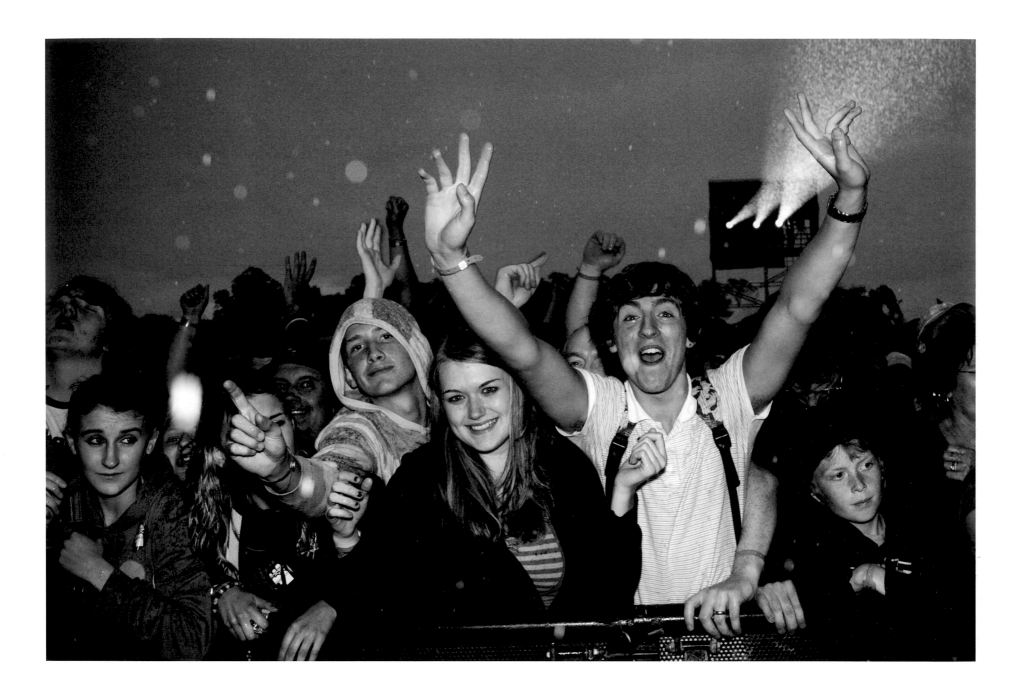

86 The crowd loving The Who despite the pouring rain at Knowsley Music Festival

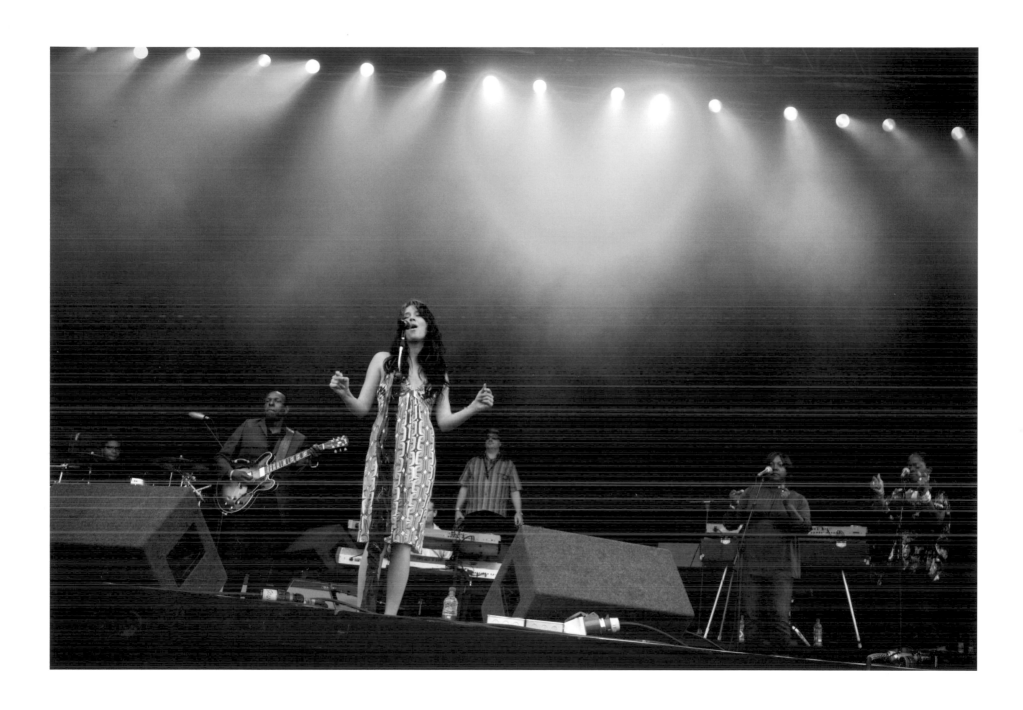

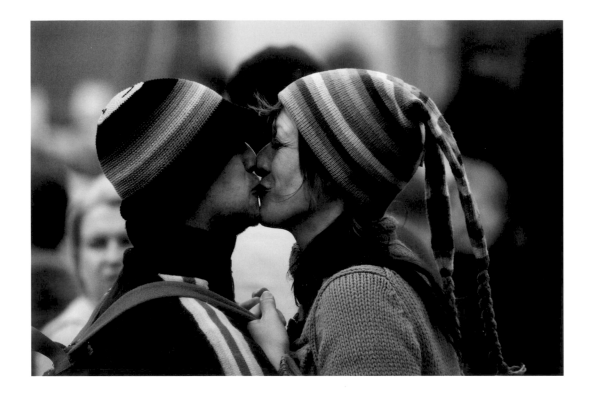

TOP: A couple kissing at Knowsley Music Festival BOTTOM: A girl dancing at Knowsley

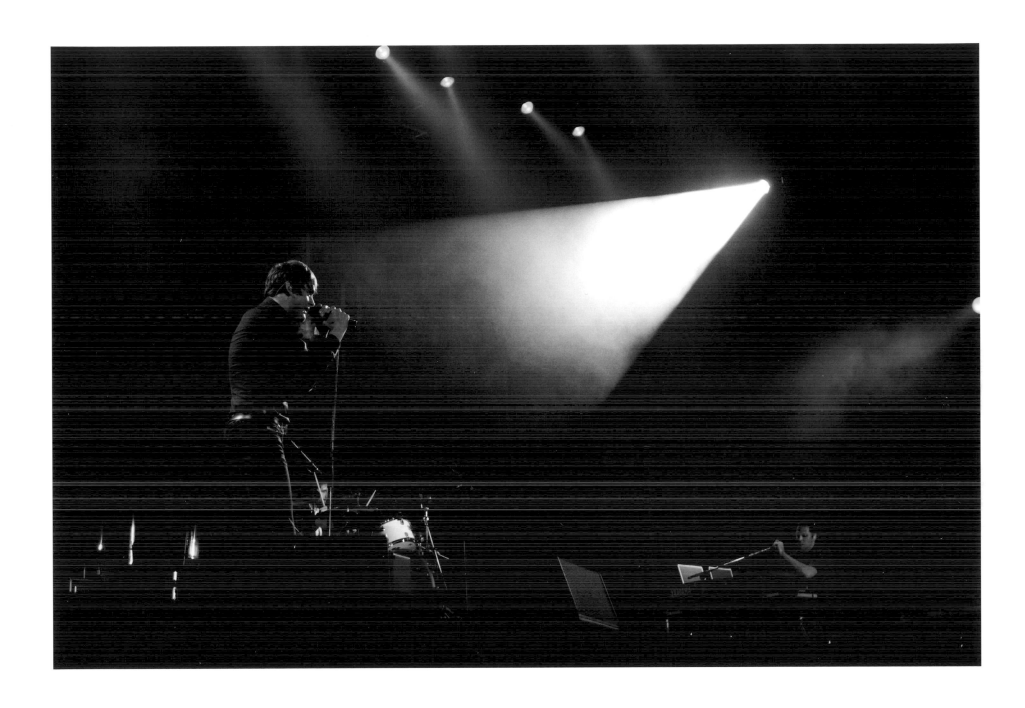

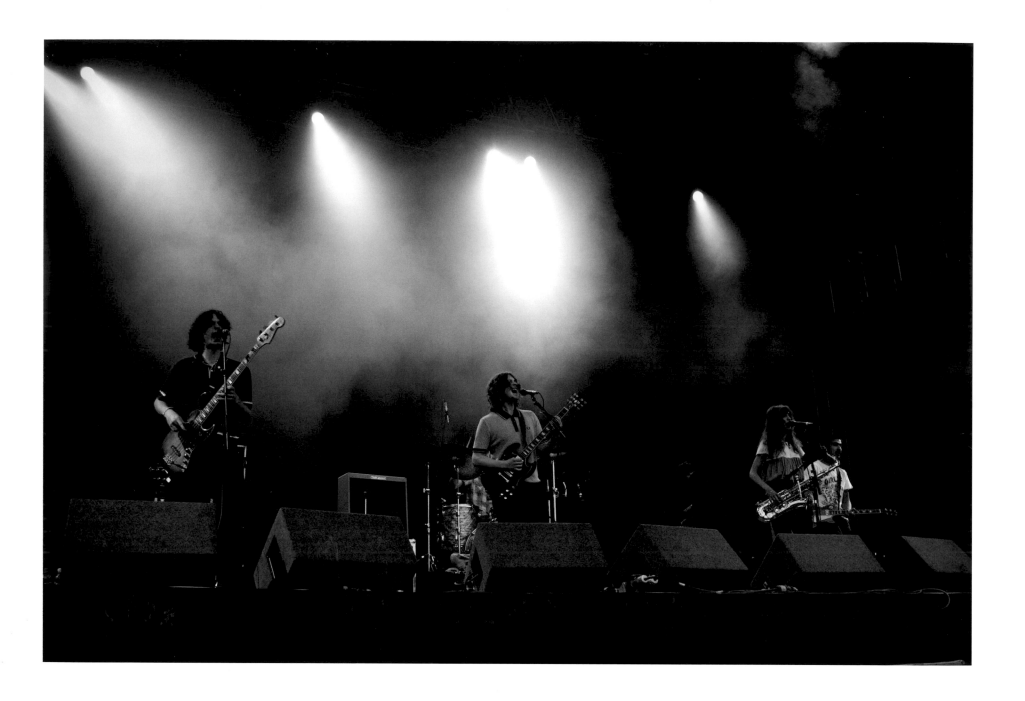

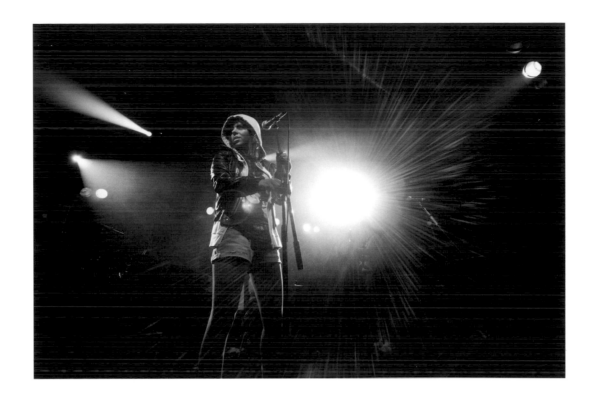

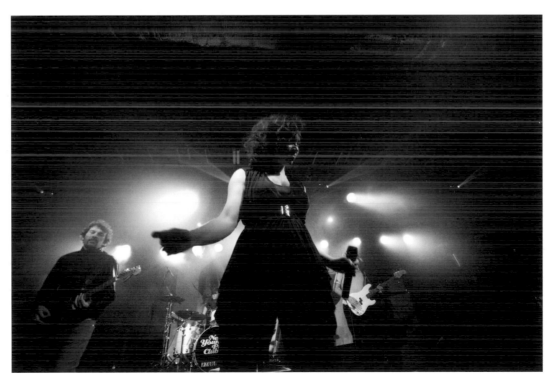

TOP: Soft Toy Emergency at Liverpool Music Week launch, 2007 BOTTOM: New Young Pony Club at Liverpool Music Week launch, 2007 **91**

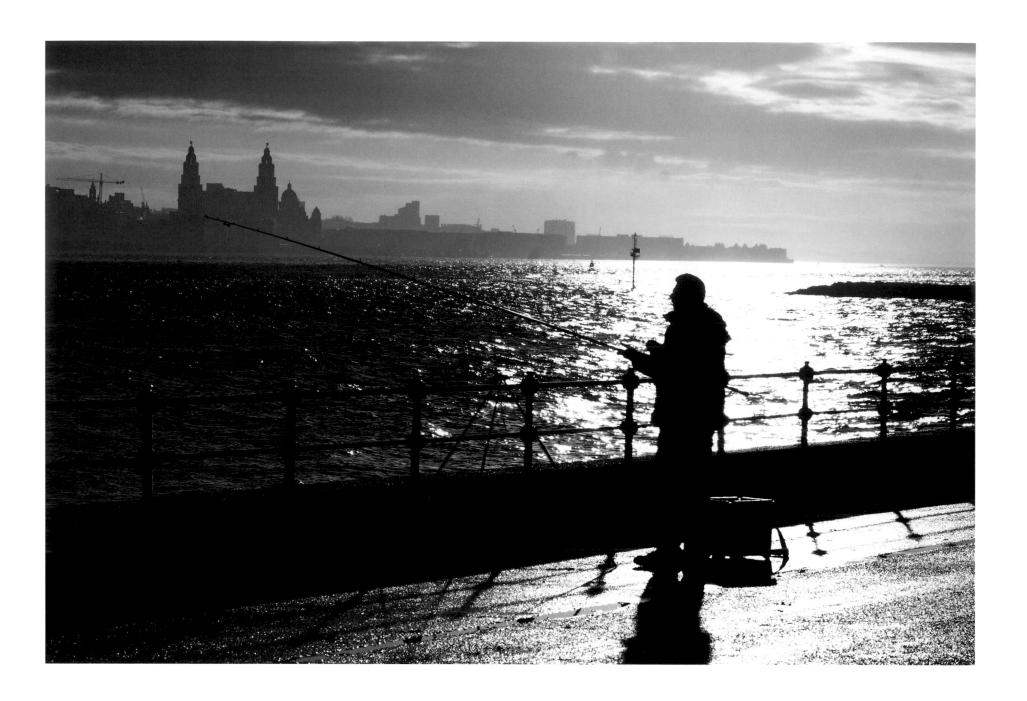

92 A fisherman getting in some early morning fishing on New Year's Day, 2006

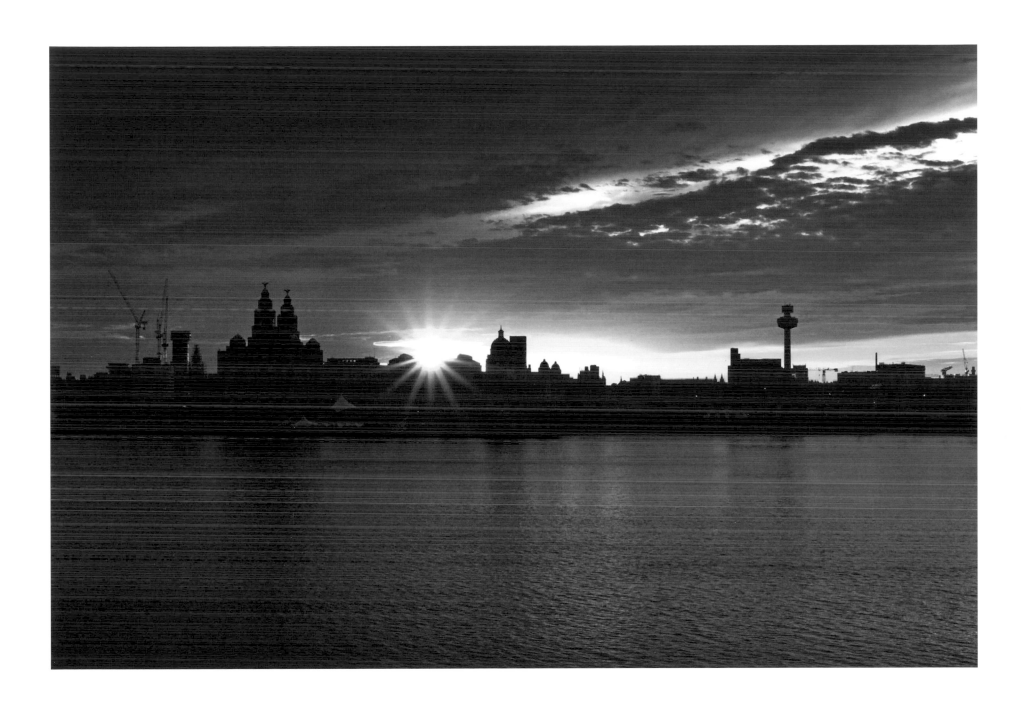

Summer solstice sunrise over Liverpool, 2005 93

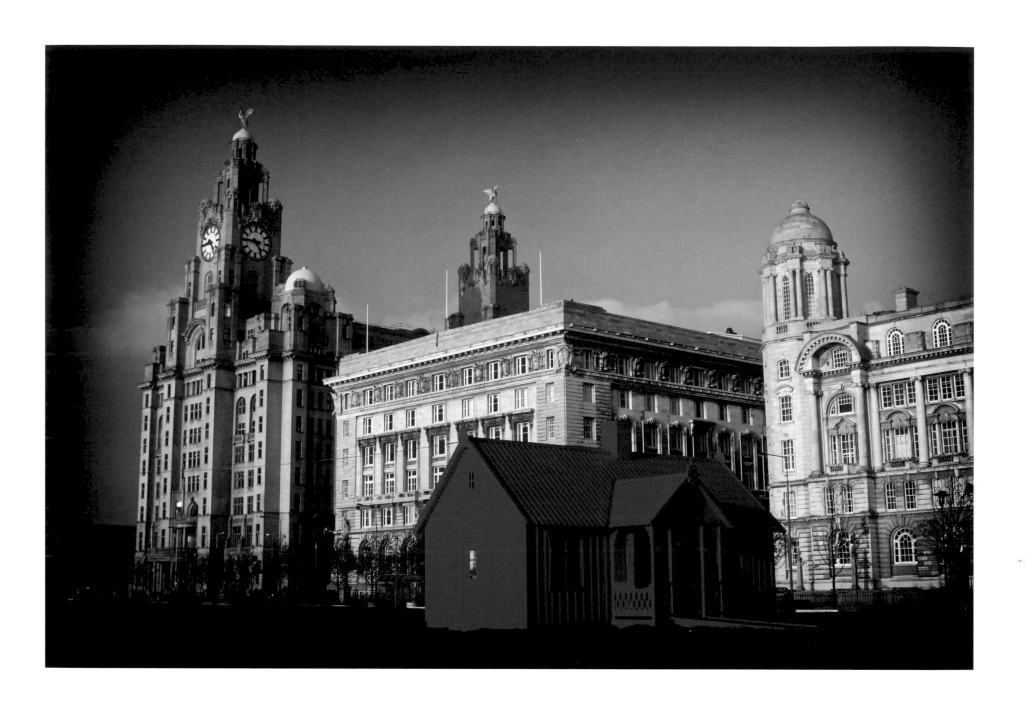

94 The Fourth Grace, the Abba Hut, Swedish Red House, as part of the 2004 Biennial

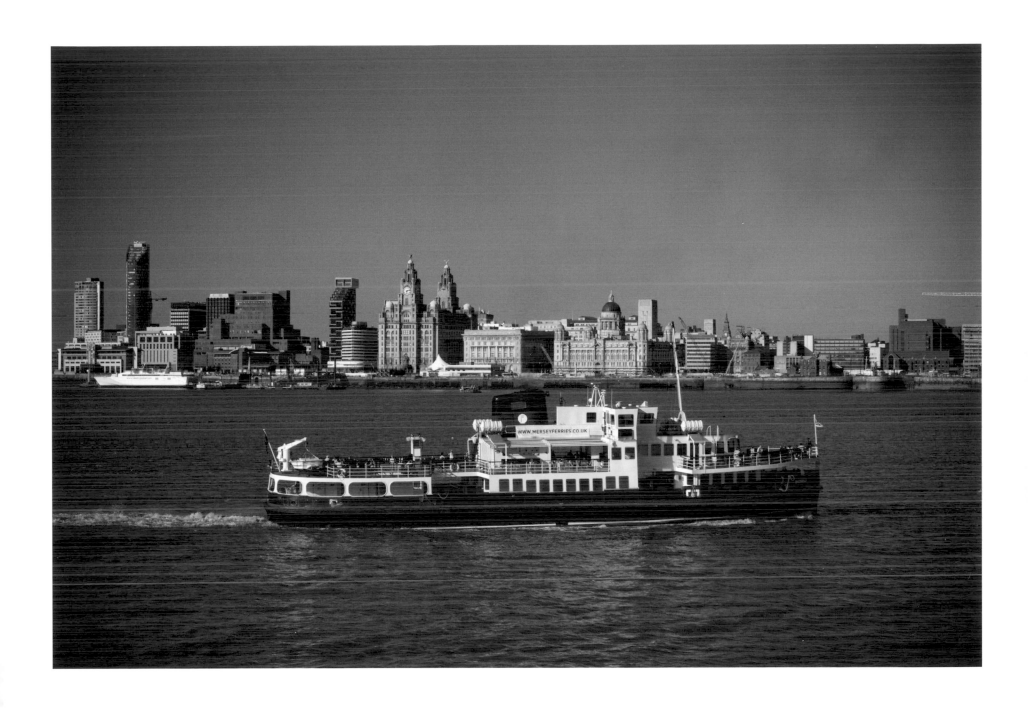

www.petecarr.net
www.vanilladays.com

Many thanks to the guys at Liverpool University Press for giving me this opportunity and to Mike March for designing the book. Thanks to all those people who've visited my website and commented over the years, it really means a lot. A very special thanks to my friends both online and offline. You guys are just awesome.